The Monkey in Art

for two little monkeys,
Alexander & Nicholas

Project Directed By Maria Teresa Train
M.T. Train/Scala Books, New York

The Monkey in Art

TEXT BY PTOLEMY TOMPKINS

DISTRIBUTED BY
ANTIQUE COLLECTORS' CLUB
WAPPINGER'S FALLS, NEW YORK WOODBRIDGE, ENGLAND

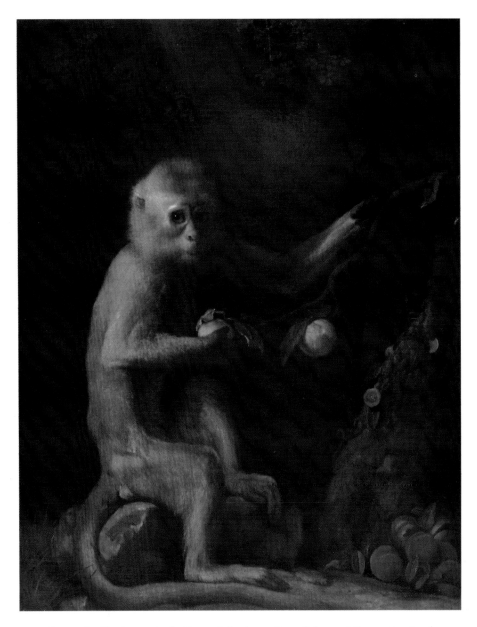

George Stubbs (1724–1806). Green Monkey. *One of the world's great animal painters, Stubbs balanced a sense of compassion and understanding for his subjects with a rigorous eye for objective detail. Yet, like so many artists before him, he was tempted further into anthropomorphism by the monkey than he was by other animals. In spite of the obvious care he took in portraying its anatomy and attitude realistically, his so-called green monkey has a decidedly human air about it.*

The Board of Trustees of the National Museums & Galleries on Merseyside. Walker Art Gallery, Liverpool.

TABLE OF
CONTENTS

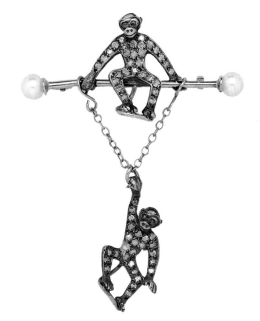

Monkey brooch. English, late nineteenth century. A pair of monkeys with ruby and emerald eyes and bodies of gold, diamonds and pearls disport themselves in this Renaissance-style brooch. Courtesy Collection of Joaillerie Wishes, Geneva.

Introduction

No artist has ever made an image of an animal that does not somehow include the human world. Whether the subject is a cat, a horse, or a crocodile, and whether the artist is a Sunday painter or a scientist, something human inevitably finds its way in before the picture is completed. This is especially so with those strangely intermediate beings, the monkeys and apes. In myth and legend, in literature, and especially in the world of art, monkeys carry the weight of human projections more often than any other animal.

They also have to bear a lot of criticism. All over the world and throughout history—and perhaps prehistory— the monkey has consistently suggested certain qualities to the human imagination, and many of these have been less than flattering. Perhaps because we have never quite been able to forgive them for reminding us of ourselves, we humans have accused monkeys of an astonishing number of faults, from the major to the petty, over the course of time.

The most persistent charge traditionally leveled against monkeys is a simple one: They don't fit. From the Pacific Islands to medieval Europe, humans have voiced a common complaint that the monkey complicates the job of dividing up the world into separate, cleanly understood categories. Especially in the West, the monkey has been chastised both for the way it looks and the way it acts, its oddly human appearance and freedom-loving ways combining to make it an enemy of order not only by its deeds but by its very existence.

Ambivalence about the monkey shows up with frequency even among primitive and archaic peoples, who as a rule enjoy a more intimate and less judgmental view of animal creation than do later, more technically advanced cultures. Tribal myths and legends of many such peoples,

Vittore Carpaccio (1465–1525). Detail of Return of the Ambassadors, *from the cycle of St. Ursula.* Dressed as a courtier but appearing rather disinterested in fulfilling the duties of his position, this aloof little monkey epitomizes the marginal role so often played by these animals in the world's art. Yet though marginal, its inclusion here is not the result of mere whimsy or accident. Like the peacock, a traditional symbol of vanity, this monkey most likely was intended to suggest another human vice: presumption. *Accademia, Venice. Scala/Art Resource, New York.*

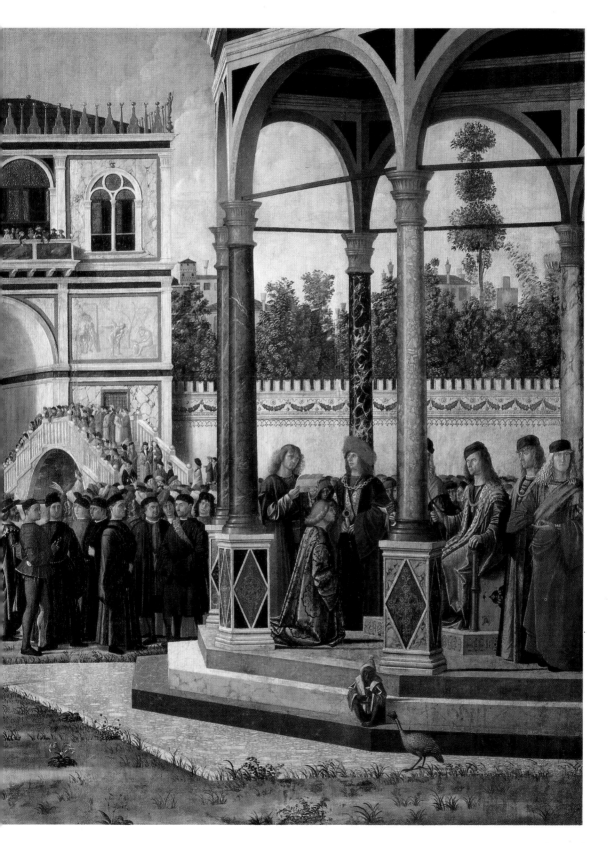

from Africa to the South Pacific to the Americas, sometimes explain monkeys as being trial runs on the road to the creation of humans—botched first attempts on the part of the Creator that were allowed to remain on Earth in spite of their somewhat embarrassing imperfections. Monkeys are also very often explained as being humans who for one reason or another fell away from their original state. An African myth, for example, states that chimpanzees are the offspring of a particularly unmotivated tribe of humans who one day tired of the strain and tedium of village life and simply abandoned it for the comforts of the jungle. In a number of other myths and tales from around the world, characters with an excess of pride or presumption are turned into monkeys as a punishment for some self-glorifying action. In Greek myth, a group of creatures called cercopes are turned into monkeys after presuming to play a joke on Hercules, while Talmudic legend states that a portion of the men who built the Tower of Babel suffered the same fate. Whether it is understood to be the result of divine punishment, divine clumsiness, or a willful act of laziness or insubordination on the part of the creatures themselves, the state of monkeyhood is often presented as a less than enviable one.

Often, but not always. For at the same time as it has called forth more than its share of criticism, the monkey has here and there recieved uncolored praise. Though the habit of criticizing and condemning monkeys shows up throughout the world, one finds considerably less of it in

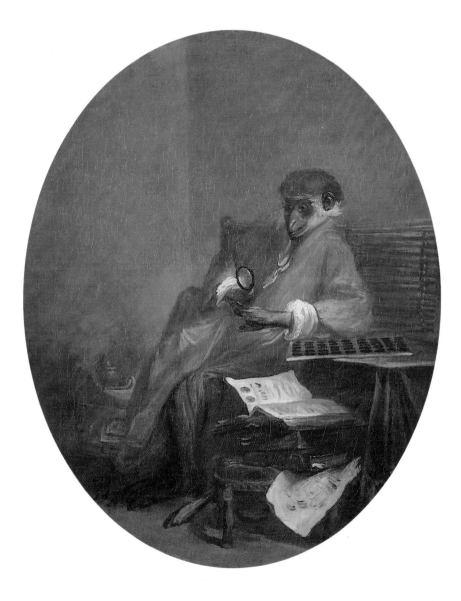

India, China, Japan, and other areas that, until recently at least, lay beyond the reach of the Western traditions and the more or less suspicious attitude toward nature that so often goes along with them. Free-living monkeys have always been, and often remain today, a common sight in much of India and the Far East, and this proximity has frequently led to acceptance and celebration of these animals rather than fear and derision. In addition, the religions of the Far East—Buddhism, Hinduism, Taoism, Shinto, and others—are generally more accepting of the animal world, including its more flamboyant and initially disconcerting members, than are the three religions of the Book. Though the role of humans is typically seen as being of some special importance in Eastern religions as well, there is a general openness outside the world of Judaism, Christianity, and Islam to treating the animal world with greater respect, and to assigning even its stranger members positive roles. Consequently there exist in the East a group of traditions and a rich fund of artwork giving expression to it, which together serve as a kind of counter-current to so much of the Western lore about apes and monkeys. Indeed, the qualities with which these animals have been invested in places like India, China, and Japan are often the exact opposite of those negative ones so often placed upon them in the West.

Seated monkey holding a cacao pod. South-central Veracruz, Mexico, Late Classic period (550–950 A.D.). While sometimes treated satirically, monkeys were also given a number of more serious roles in the ancient Americas. Among the Classic Maya, for example, they could serve as symbols for sexuality. The symbolic intent behind sculpted figures is not always clear, however, and pieces like this clay vessel from Veracruz might simply have been products of artistic whimsy.

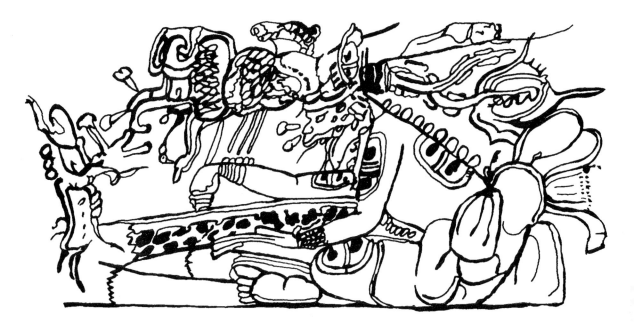

Monkey Scribes. This illustration, taken from a classic Maya vase, shows a monkey scribe writing in a codex bound with jaguar skin. Because they look at once like humans and like animals, monkeys were often thought to act as messengers between the human community and the world of nature or the gods. The ancient Greeks associated them with Hermes for this reason, and in places like Africa and South America they could act as representatives of the collective spirits of the forest. Perhaps because of this reputation as messengers they also served as patrons of the scribal arts for a number of cultures. These include the ancient Egyptians and the Maya of the Yucatan and Guatemala, who frequently included monkeys in their complex images of the underworld.

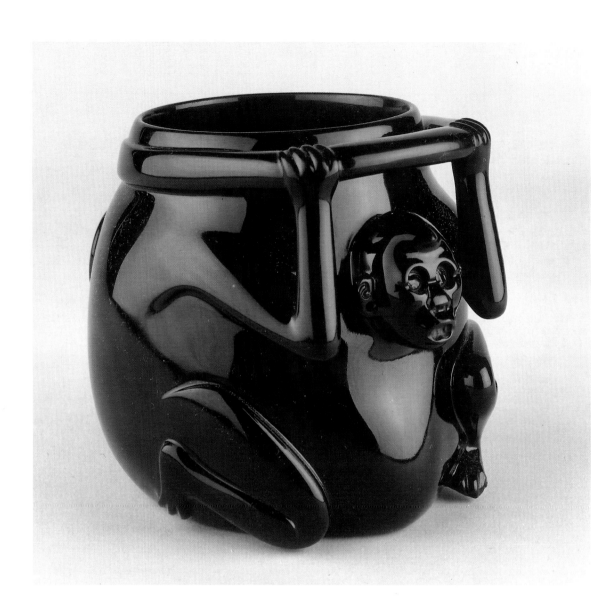

Though known primarily for their more imposing and serious religiously motivated works, many of Mesoamerica's native cultures also possessed a flair for more modest and whimsical creations. Monkeys, such as the ones represented on these two Mexican vases, were popular subjects for such works.

ABOVE: *Post-conquest obsidian vase with an image of a pregnant monkey. From Texcoco, fifteenth century.*

RIGHT: *Precolumbian onyx vase representing a squatting monkey, its tail forming the vase's handle. From the Island of Sacrifices in the Gulf of Mexico off Veracruz.*

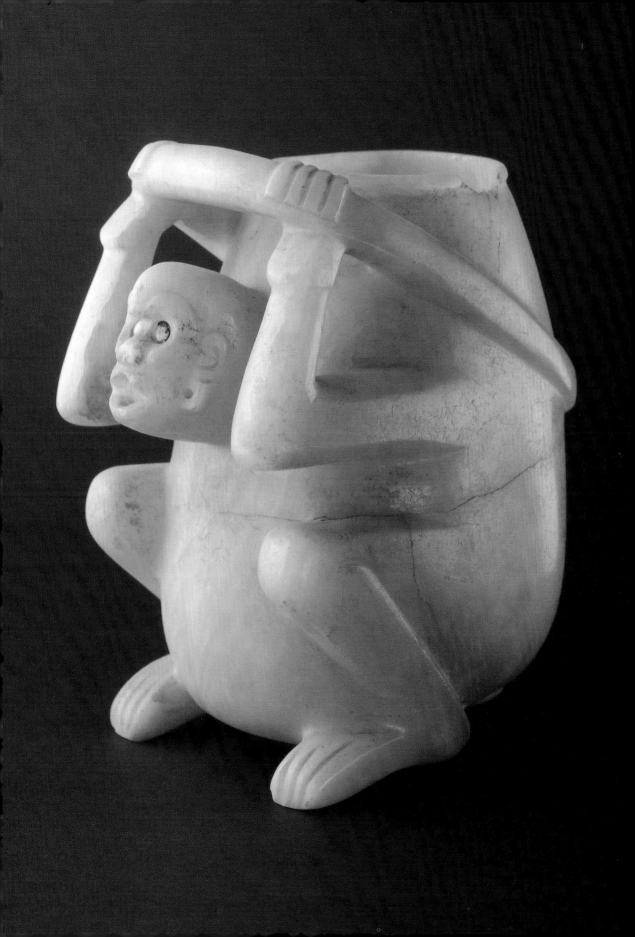

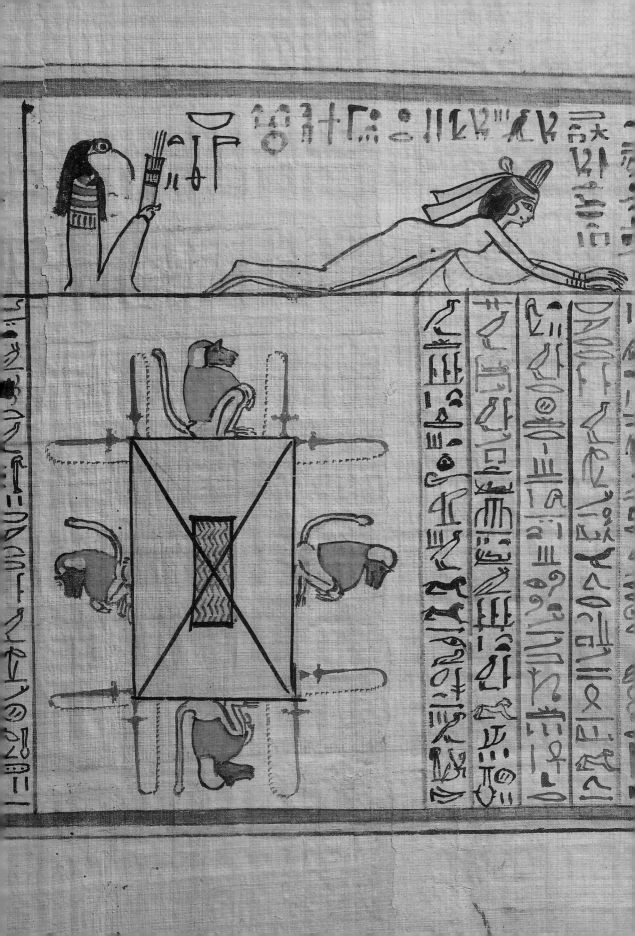

The Ancient and Classical Worlds

The monkey of the Western artistic imagination got its start with the ancient Egyptians, who, unlike so many of the cultures that came after them, seem to have seen these animals not only in an objective but also almost entirely positive light. Though celebration of the monkey as an embodiment of the divine was much more an Eastern habit than a Western one, it was in Egypt, at the great dawn of Western culture as we know it, that the longest and most consistent religious glorification of the monkey was carried out. Cultures that revere rather than insult monkeys tend to single out one species for particular praise, and in Egypt this was the yellow or hamadryas baboon. The Egyptians imported these creatures in quantity from nearby Ethiopia and trained them as temple guardians.

Though monkeys, not apes, and thus evolutionarily far more distant from humans than anthropoids like the chimpanzee, baboons are highly intelligent and sensitive creatures whose social habits have recently been found to be surprisingly similar to those of humans. That sophistication seems not to have been lost on the ancient Egyptians. Though the assertions of later Roman writers that Egypt's temple baboons dined daily on gourmet meals cooked just

Detail from a Papyri. Thebes, Deir el Bahri. Third intermediate period, twenty-first Dynasty (c. 1039–991 B.C.). Funerary papyrus of the songstress of Amun Nany, with selections from the Book of the Dead. This detail shows four baboons seated around an afterlife landmark known as the lake of fire and Nany prostrate before the rising sun. From the tomb of Queen Merit-amun.
Excavations of The Metropolitan Museum of Art, New York, 1929; Rogers Fund, 1930 (30.3.31).

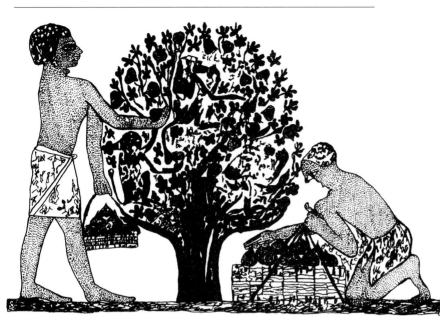

to their liking and washed them down with fine wines should perhaps not be trusted, it appears that these animals were very well tended in exchange for their duties.

In moments of repose the baboon strikes a characteristic sitting position immediately recognizable in many Egyptian renderings of this animal. Baboon troops often assume this pose for long periods in the morning hours, when the rising sun gradually gathers in intensity. Perhaps because of this the baboon is often connected, in Egyptian myth and lore, with the sun and its daily and nightly course through the over and underworlds, just as it is with that other most noticeable heavenly body, the moon.

Like so many other ancient peoples, the Egyptians saw the moon's monthly phases as a celestial mirroring of the various cycles of barrenness and fruition that occur on a smaller scale down on Earth—especially the human menstrual cycle. All female primates share this cycle with humans, and to the intensely observant Egyptians this parallel between human, animal, and heavenly bodies could only be seen as highly significant. The association of baboons and the moon was passed on to the ancient Greeks, who passed it on to the Romans, who in turn bequeathed it to medieval Europe. Consequently, the various bestiaries of the Middle Ages are full of descriptions of the harrowing

Baboon Fig Pickers. The monkey's nimbleness and grace were sometimes the subject of uncolored praise in the ancient world, and could be taken advantage of at harvest time. In this ancient Egyptian drawing, two fig pickers appear to be assisted by a trio of baboons. Drawn from a wall painting from the tomb of Khnum-hotep at Beni Hasan, c. 1890 B.C.

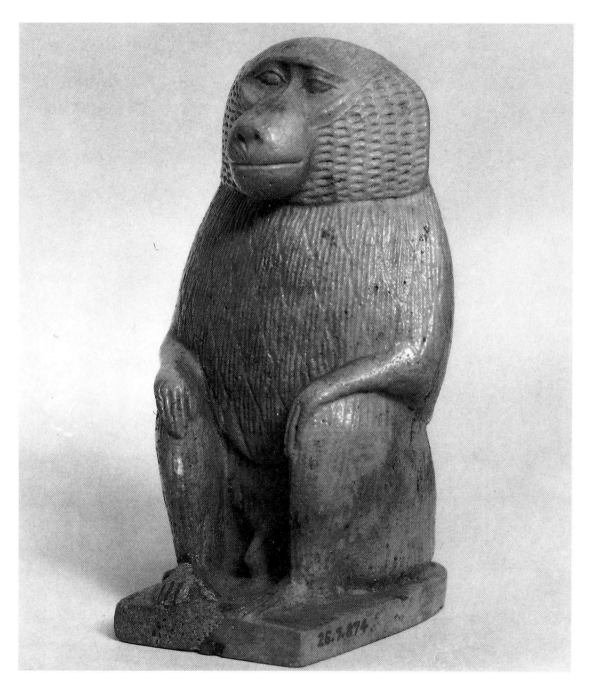

The baboon was among the animals accorded the highest respect by the ancient Egyptians, and a great number of works depicting it survive. Much maligned in the classical and Christian West for their religious glorification of nature, the ancient Egyptians were in fact the architects of a sophisticated body of religious, philosophical, and scientific knowledge. The Egyptians saw the universe as a living entity, whose countless spiritual forces were embodied in the forms of living creatures and natural phenomena in general. The baboon played a number of roles in this spiritually saturated world, but was most strongly associated with Thoth, the god of wisdom. The Metropolitan Museum of Art, New York, Gift of Edward S. Harkness, 1926 (26.7.874).

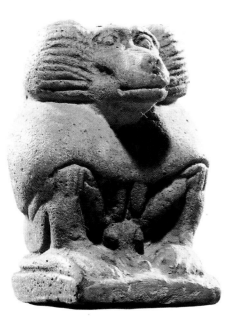

Representation of the God Thoth, ceramic-faience 662 B.C. Though their culture revered it as an embodiment of the divine, Egyptian artists sometimes treated monkeys with a lighter touch. However, this was generally the case with species other than the sacred baboon. A number of such species were imported into Egypt with frequency, and mummified specimens have even been found. Courtesy of The Ariadne Galleries, Inc., New York.

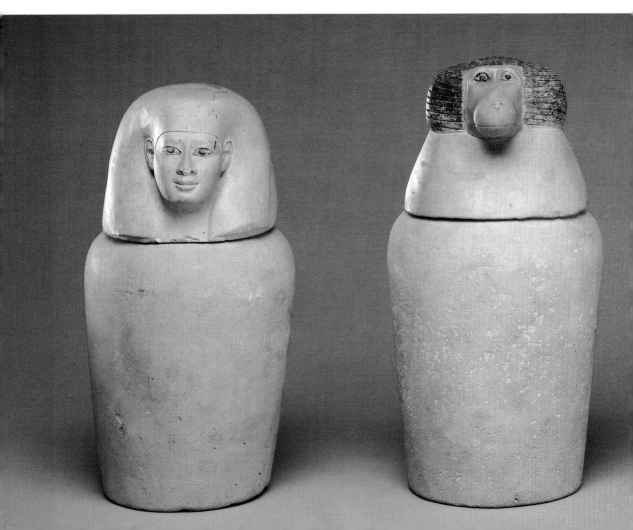

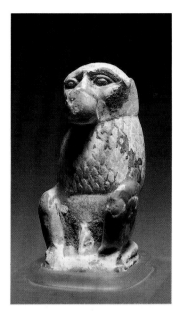

Canopic jars. Limestone. Twenty-sixth-thirtieth Dynasty, c. 656-342 B.C.
Egyptian culture was keenly and subtly concerned with the
fate of the human soul after death, and much of its art relates directly to
the shape and nature of the afterworld. Canopic jars, which held the
chemically treated insides of the dead, were placed in tombs near the
mummified body. Baboon heads, along with those of a jackal, a falcon,
and a man—together representing the four "sons of Horus"—were
typically sculpted on the lids.

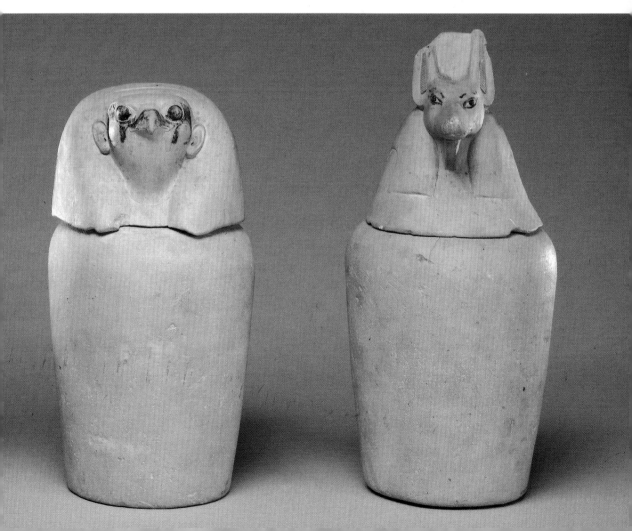

moans that baboons, and sometimes monkeys in general, supposedly send forth at the time of the moon's waning and of the wild jubilation with which they greet its return.

Egyptian myth associates the baboon most strongly with Thoth, the ibis-headed god of wisdom who presides over the weighing of the hearts of the dead to determine the shape and character of their deeds in life. The baboon's image is therefore often encountered in texts dealing with the Egyptians' lengthy and intricate vision of the afterlife journey, as well as on scales and measures used for more everyday purposes.

Though they too knew them only as imports, the ancient Greeks were quite familiar with monkeys and, like the Egyptians, on occasion took them into their households, training them to do tricks and perform simple chores. But with the Greeks the older, positive view of monkeys as creatures whose strange combination of human and animal qualities called for veneration and respect came to a decisive halt. To judge from the elegant blue monkeys that play about the Wall of Frescoes from the Palace of Minos on Crete, a reverence, or at least an appreciation, for the monkey once existed in the area. But by classical times this attitude was less in evidence, the monkey being more often a subject of vigorous, if usually quite casual and humorous, disdain.

This low view is especially evident within the fables that have come down to us from those times. Many animals have served as negative figures for artists and storytellers throughout history, but the monkey in these tales was often denied even the relative consolation of status as a

Ape with Bread Pan. *This simply molded figure manages to suggest the features of a monkey using tremendous economy of detail. Cyrenaica. Louvre, Paris. Cliche des Musées Nationaux, Paris.*

genuine villain. Unlike such supposedly evil animals as the fox or the wolf, the monkey of Greek and Roman fable was condemned by its troublesome in betweenness to be cut off not only from humans but also from the more conventionally designed members of the animal kingdom, who as a rule want to have nothing to do with it.

As a result, the monkey of these stories spends much of its time pretending to be other than what it is—usually unsuccessfully. In one ancient Greek fable that eventually made its way into the collection we associate with Aesop, a ship with a monkey aboard sinks. In desperation the monkey attempts to persuade a passing dolphin that it is a man and therefore merits rescue. The dolphin falls for the pretense at first, but after a few carefully devised questions sees the monkey for what it is—and lets it drown.

This lack of respect followed the monkey out of the realms of myth and fable and into other areas of understanding. Like the Egyptians, the Greeks took careful notice of the close physical similarity between monkeys and humans, but to them this was at best a laughable curiosity and at worst an affront. William P. McDermott writes in his classic study *The Ape in Antiquity* that in ancient Greece, even strictly scientific descriptions of monkeys occasionally lapsed into a joking mode. The Romans after them held to the same opinion, and Egypt's praiseful attitude toward the monkey became a subject of no small amusement to many a Roman writer. "Who does not know," wrote the Roman satirist Juvenal, "what monsters are revered by demented Egypt? One part worships the crocodile, another goes in awe of the ibis that feeds on

Arthur Rackham (1867–1939). Illustration for The Monkey and the Dolphin *from "Aesop's Fables." Dolphins are often credited with rescuing humans from drowning in classical literature. The idea was attractive to story-tellers, and gave rise to a popular tale in which a presumptuous monkey unsuccessfully seeks the same favor for himself. In this modern illustration for Aesop's Fables, Arthur Rackham places a chimpanzee—an animal most likely unknown in ancient Greece—on the dolphin's back.*

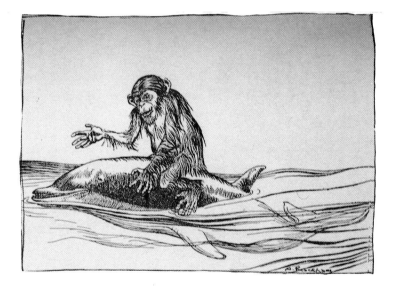

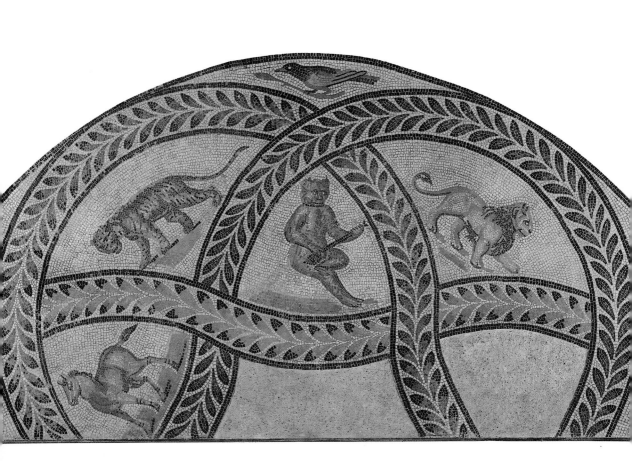

serpents. Elsewhere there shines the golden effigy of the longtail monkey." The general view the classical world held of the monkey was perhaps best and most succinctly summed up by another of these writers, Claudius Ennius, when he wrote of "the ape, that vile beast, so similar to us." Bridging the domain between animals and humans, the monkey of the classical imagination thus often found itself reduced to a status beneath both.

Mosaic from Hadrumetum. Orpheus charming the animals was an extremely popular theme among the ancient Romans. The majority of works representing it occur in mosaic form. The monkey's role in these scenes was often ambiguous. At times it appeared enchanted along with the rest of nature by the magical lyre, while at others it seemed mockingly contemptuous of it. In this case, the monkey assumes the role of Orpheus himself. Such scenes sometimes received a later, Christian interpretation, in which case the mocking monkey took on demonic overtones because of its seeming derision of Christ's message. Louvre. Photo R. M. N., Paris.

Market scene with two little monkeys attracting customers. Part of a bas-relief. Roman, third century B.C. Despite their often appalling record for destroying them in public spectacles, the ancient Romans were fascinated by animals and left many detailed works depicting creatures ranging from lions and elephants to small, unimposing sea creatures. Though often described in less than flattering terms in Roman literature, monkeys seem to have been popular pets in ancient Rome and appear in a number of works showing scenes from everyday life. Performing monkeys were common as well, and images survive of them engaging in a variety of tricks and stunts—among others, driving a tiny chariot. Museo Ostiense. Ostia, Italy. Erich Lessing/Art Resource, New York.

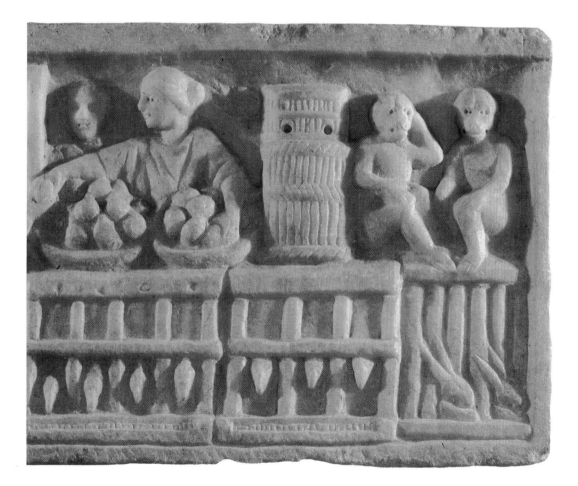

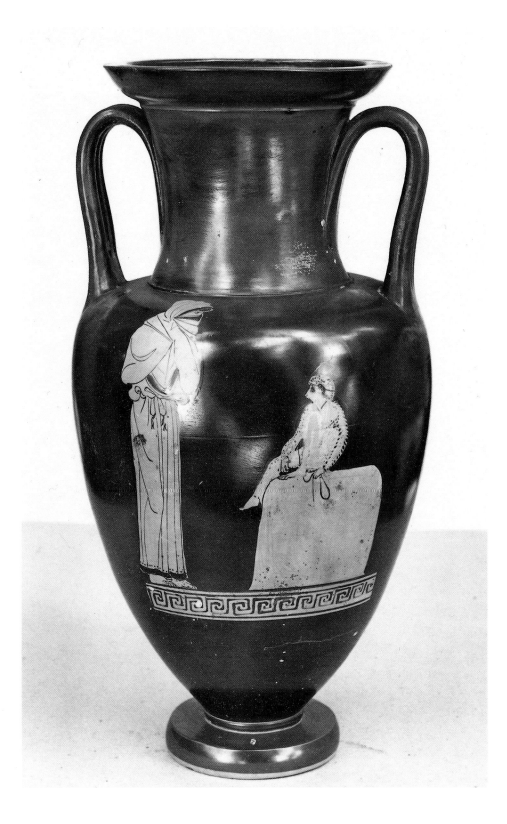

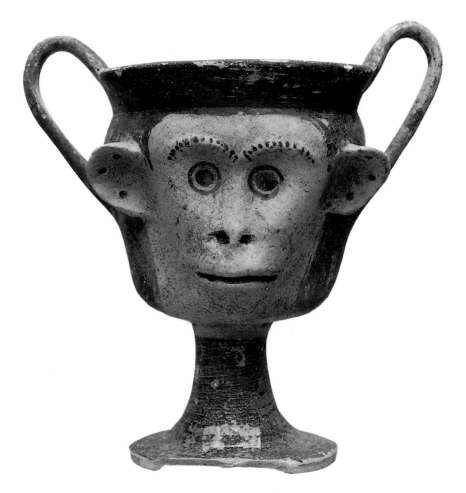

ABOVE: *Two-handled cup with monkey's face. Cyprus, early Iron Age—
Late Period (750–500 B.C.). The ancient Greeks loved to incorporate
animal images into utilitarian objects. Though they were not always
kind to the monkey, they could sometimes, as here, create images that
celebrated its form instead of ridiculing it.*
*The Metropolitan Museum of Art, New York. The Cesnola Collection;
purchased by subscription, 1874–76 (74.51.369).*

LEFT: *Red figure amphora. Greek, fourth century. B.C. Monkeys have
long been associated with deceit and betrayal of one kind or another, and
the idea continues to appear today when someone who fools someone else
is said to have "made a monkey" of them. This amphora is believed to
illustrate a scene in which a bride, mourning the death of her husband, is
informed by the spirit of a monkey that her husband is in fact still in the
world of the living—but elsewhere.*
British Museum, London.

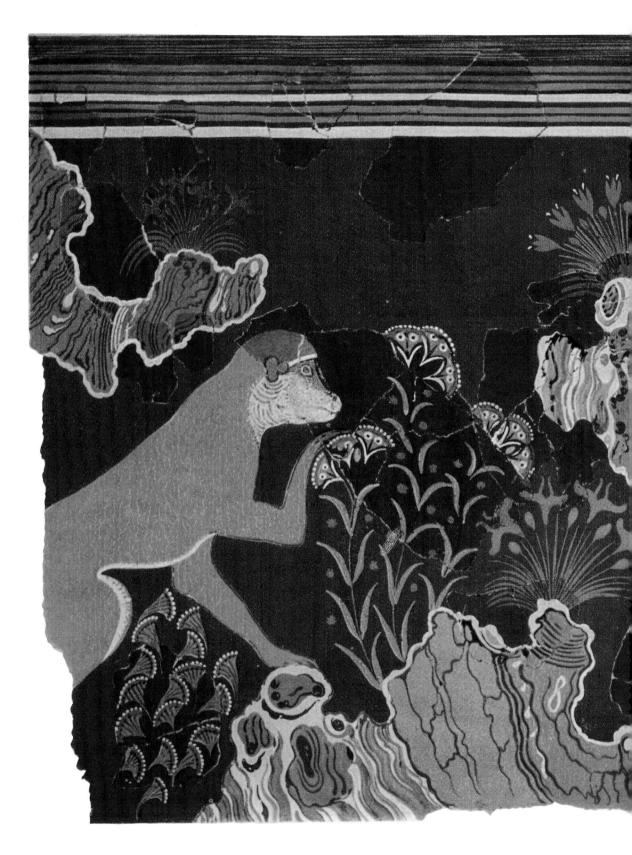

Blue monkey in rocky landscape. Minoan art stands distinctly apart from that of nearby Greece, bearing a stronger affinity with that of ancient Egypt. Contact between the two civilizations is believed to have been extensive, and it is possibly from the Egyptians that Crete received its first captive monkeys. A series of these appears on the Wall of Frescoes at the Palace of Minos. Fluid, weightless, and very appealing, these monkeys suggest the cheerful, deeply felt reverence for the natural world characteristic of Minoan society. There is in them none of the satirical condescension that would infect so many of the monkey images from mainland Greece centuries later, and also unlike so many of those later images these monkeys are depicted free and at ease in the landscape rather than as captives. Restored drawing by E. Gillieron and Sons. Detail from the House of the Frescos at the Palace of Minos at Knossos on Crete.

The Middle Ages—
From Sinner to Comic

Along with its obvious resemblance to humans, it was, curiously enough, the monkey's high intelligence which let it in for all this insult and mockery. In ancient Greece the ability of monkeys to rapidly learn how to perform various human tasks often worked against them, for it furthered the idea that the monkey was overstepping its assigned place in the hierarchy of nature and presuming to be a human.

With the arrival of Christianity, this notion of the monkey's supposed presumptuousness took on a new and entirely more ominous flavor, for it naturally called to mind that greatest of all presumers, the Devil. The equation of monkeys with the Devil was encouraged in Christian eyes by the fact that these animals were held in such high esteem by the Egyptians, while the Egyptians' dark reputation as the most shameless of idol worshipers was in turn strengthened by their admiration for the monkey. Though others had found time to voice disdain at Egypt's predilection for bodying its religious beliefs in the forms of the animal world, the Christians responded with unprecedented emotion. Investing the natural world with divinity was bad enough, but the attention accorded by the Egyptians to the baboon struck Christians as particularly heinous, and when they had amassed the numbers and means to do so they wasted no time in giving open expression to their feelings. In his definitive study *Apes and Ape Lore in the Middle Ages and the*

Fragment of a bowl from Cabirium. This threatening figure is thought by some to be a representation of an anthropoid ape, perhaps a gorilla or chimpanzee. How much contact the ancient world had with anthropoids is uncertain, as the accounts of ancient travelers and historians are generally too vague to prove the issue one way or the other.

Renaissance, art historian H. W. Janson writes of an incident that took place during a series of anti pagan riots in fourth-century Alexandria:

> *The Christians, led by Bishop Theophilus, drove away the pagan priests and destroyed the pagan temples and idols with one exception: Theophilus commanded them to preserve a statue of an ape and to set it up in a public place, as a monument to heathen depravity.*

Ugliness and evil went hand in hand in the classical mind, and as monkeys were generally considered to be ugly in those times, the idea that they were evil followed naturally. Even so, and despite the fact that the first stated equations between monkeys and demons of one kind or another came not from the early Christians but from the ancient Greeks, no one really bothered to see monkeys as genuinely evil until the arrival of Christianity. With it, the association became not only logical but urgent; the monkey's humanlike qualities were once again duly noted, only this time they were read not as some quaint joke on the part of the gods but as evidence of a much more consequential act of disobedience against the one God and all he stood for.

The first monkeys of Christian art are unambiguously wicked creatures, their dark, spidery bodies bristling with a vaguely sexualized menace that seems to compress within itself everything in the natural world that was frightening or troubling to the Christian mind. The fear and trembling that early Christian writers and artists sought to engender through their portrayal of the monkey is all the more interesting when one considers that they were not even familiar with any of the true anthropoid apes—the chimpanzee, the gorilla, the orangutan, and the gibbon—which in behavior and appearance bear the most striking resemblance to humans. Until the end of the Middle Ages Christian Europe was familiar only with smaller, distinctly un-satanic varieties collected from coastal North Africa—species that we today would be more likely to associate with organ grinders than the Devil.

This menacing little monkey from the Barberini Psalter sports a modest—and incongruous—skirt. The "naked" look of monkeys and apes was one of the reasons for the widespread Christian belief that they were evil.

Probably because of the basic unsuitability of these little monkeys for the part, the monkey-devil association did not stick for long. Demoted from the role of the Devil himself, the monkey of Christian art was soon thereafter assigned what was in effect the next best thing: the role of the Devil's victim the deluded sinner, who in payment for his raging carnal appetites and forgetfulness of God must endure an eternity of torments and tortures.

This new image found its strongest expression in the Romanesque period, in the works of which monkeys in plentiful numbers can be seen either suffering the punishments of hell or pursuing the ways of sin and excess that lead up to them.

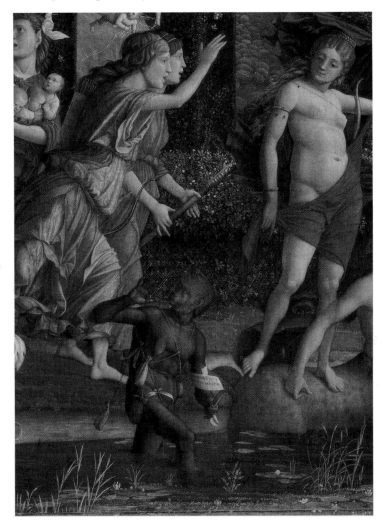

Andrea Mantegna (1430–1506). Detail from Minerva Chasing the Vices from the Garden of Virtue. *Throughout history, both in the West and beyond, monkeys have frequently served as symbols for what used to be called the "lower" or "baser" side of humanity. The idea that man is part ape and part angel, just as the ape is itself part animal and part man, suggested its use as a symbol for the animal side of humankind in Christian art.*
Louvre, Paris. Photo R. M. N., Paris.

Engaged church column from Portugal featuring a whimsically carved, violin-playing monkey. Photo by Chester Brummel.

Gasping, wincing, and contorting themselves, these monkeys line the margins of Romanesque manuscripts and appear along the crowded stone faces of Romanesque churches. These unfortunate figures are monkeys only in a technical sense, the proportions of their limbs and bodies and the expressions on their faces suggesting men in monkey suits more than actual animals. But elsewhere in the world of medieval art another, slightly more realistic-looking version of the monkey-sinner began slowly to emerge. Hunched, squinty-eyed, and conspiratorial, these characters were most often found not in books or stone but in paintings—particularly paintings dealing with Adam, Eve and the Fall.

Human beings, as Janson pointed out, tend to be what he called Darwinists in reverse in their thinking about monkeys and apes. By this he meant that it has been a common habit over the centuries to read the humanlike qualities of simians as evidence of a falling away from human perfection—a falling away that the myths and tales of many cultures suggest the monkey must, at some time in the past, have done something to deserve. The practice of placing a monkey within the confines of Eden—which got its start in the Romanesque and remained popular throughout the Gothic period and beyond—is basically a continuation of this old idea in a Christian guise. Being a debased or "fallen" human itself—as certain myths from Oceania to Africa to the Americas state—it makes sense that the monkey might be tempted to lure Adam and his mate into the same fate. And this, in work after work, is precisely what it can be found doing throughout the Middle Ages.

Skulking about at the edges of medieval art year after year, these looming Edenic monkeys gradually accumulated a symbolic arsenal that helped them to better embody the ever-waiting forces of sin and corruption in whose cause they worked. In classical times monkeys holding apples were a favorite subject for painting and sculpture, and this once benign theme was revived in the Middle Ages and given a sinister new twist through its Christian context. In addition, the chains which, sadly, often restrained captive

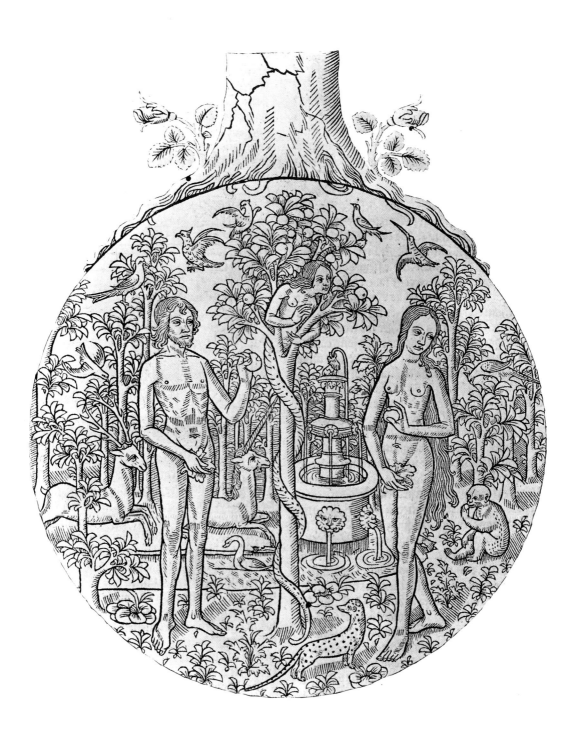

The Temptation of Adam and Eve. *A page from "La Bible en Francoys", Paris, by Verard Antoine. Print XVI, c. 1500. This woodcut shows an apple-eating monkey assisting the serpent in urging the first couple toward the Fall from paradise. In some cases, artists found the monkey such a useful symbol for Adam and Eve's transgression that they removed the serpent altogether. The Metropolitan Museum of Art, New York. Harris Brisbane Dick Fund, 1924 (24.16.1).*

Monkey with stolen baby. From "Hours of the Virgin," illuminated manuscript produced in Flanders during the first part of the fifteenth century. One of the most popular notions entertained about monkeys in the classical and medieval world concerned their supposed proclivity for the young of other creatures—especially humans. Here a monkey has made off with a sleeping child. The Pierpont Morgan Library, New York, M.358, f.11.

monkeys in real life were increasingly included in order that their ready symbolic potential could be exploited. Monkeys in the art of the Middle Ages thus typically appear either in a tree (often the Tree of Knowledge itself, conveniently supplied with apples) or chained to the ground, sometimes with half-eaten fruits and nuts scattered about to symbolize the carnal pleasures that were generally understood to be the true chains binding man to earthly existence.

In the course of its brooding career on the edges of medieval art, the monkey's old habit of imitation would now and then overtake it. In addition to "aping" the gestures and actions of humans, it might also be seen imitating birds—those ancient and universal symbols of the higher life of the spirit.

The twelfth-century abbess and mystic Hildegard of Bingen gives an interesting commentary on this supposed

habit in her *Physica*, a treatise on medical lore and speculation:

> *Since he is rather similar to man, he always observes him in order to imitate his actions. He also shares the habits of beasts, but both these aspects of his nature are deficient, so that his behavior is neither completely human or completely animal; he is therefore unstable.*

Sometimes, when he observes a bird in flight, he raises himself and leaps and tries to fly, but since he cannot accomplish his desire he immediately becomes enraged.

In the ancient world monkeys were sometimes used as convenient props for the derision of women (women who were considered ugly, for example, were often compared with them), and in the medieval world this tradition was revived, the sinful and dishonest monkey now being compared to Eve and vice versa. Like the monkey, this theory ran, Woman was by nature a secondary approximation of Man,

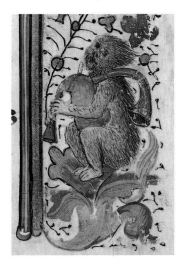

and this reduced status ultimately led her to tempt Adam into the act that would result in his expulsion from Eden. In a sixteenth-century woodcut by Erhard Altdorfer, this equation of Eve and the monkey as dual culprits in engineering Adam's downfall achieved perhaps its strongest, most unambiguous expression. In the

Details from an illuminated manuscript. Italian, fifteenth century. Though they played no part in the actual texts, monkeys were curiously popular figures on the margins of the medieval Books of Hours, where they served as tools for satire

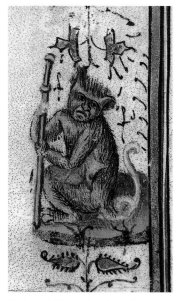

that could be either broad or specific, depending on the demands of the occasion. These monkeys from a fifteenth century codex produced in Parma, for example, probably refer to a specific public figure of the time.
Courtesy Biblioteca Palatina di Parma.

picture two monkeys appear in the branches of the Tree of Knowledge—more or less where one would expect the serpent to be—the female brandishing an apple before the male. Janson, in his exhaustive exploration of the monkey's transformations in this period, describes the scene as follows:

> *Adam and Eve have not yet begun their fatal harvest, but we can see the idea taking hold in their minds. Eve, squatting in front of her spouse at the foot of the Tree of Knowledge, excitedly points upwards at a pair of apes disporting themselves among the branches. The smaller of the two, presumably the female of the species, has just plucked an apple and is offering it to her companion, who leaps eagerly toward the proffered fruit. Thus the simians, by demonstrating how easily and pleasantly the forbidden act can be performed, persuade the human couple below to follow their example and to brave the consequences.*

With its consolidation as a key figure in the Garden of Eden, the monkey secured itself a lasting place in the medieval imagination. But, true to its nature, the monkey did not rest content with this role. Year after year the monkey's symbolic associations with sin, with an ungodly presumption to human status, and with the chains of *ap petite* that kept the human spirit in the shackles of the flesh grew ever more standardized. But elsewhere in the art of the Middle Ages it was developing a kind of alter ego whose character and actions were very different from all this. As Gothic attitudes gradually replaced those of the Romanesque, the humorous, satirical *drôleries* that appeared on the margins of manuscripts throughout the Middle Ages became an increasingly significant vehicle for lively—and often astonishingly bold—social commentary; and within these confines the monkey soon became a figure of the first importance.

Monkeys are featured in Gothic *drôlerie* more often, and in a more outlandish catalog of situations, than any other animal. While elsewhere in the art of this period it languished in chains or clutched miserably at the apples and nuts of carnal attachment, in the topsy-turvy world of the

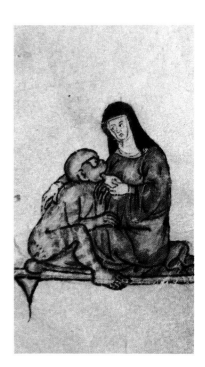

Nun Suckling a Monkey. Illumination from the Lancelot Romance. Medieval marginal illustration was not only bold but often quite sophisticated in its satire. This image of a nun suckling a monkey plays daringly on traditional images of the Christ child and the Virgin in order to point up the falling off of monastic discipline. John Rylands Library, Manchester.

drôleries, where the underdog emerged on top and the pompous and powerful suffered various embarrassments and humiliations, the monkey became perhaps the chief protagonist in a highly significant—if, by its very nature, "marginal"—revolt against the confinements and hypocrisies of medieval society.

Whether riding about on a white unicorn in mocking imitation of the ideals of chivalry, solemnly conducting a liturgical service with a giant owl to parody the church and the priesthood, or even nursing at the breast of a curiously complacent nun, the monkey of the Gothic *drôleries* was not simply a scapegoat or fool but something ultimately more complex and positive. The ridiculous antics it performed while running about in the costumes of the high and mighty contained an exuberance and energy that suggested that not only were the religious and political powers of the time open to ridicule, but that the spirit of that ridicule was valuable in its own right.

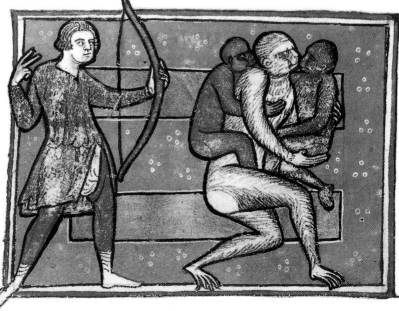

The Renaissance and
The Monkey Dance

Thus, after centuries of shouldering an assortment of human fears, guilts, and insecurities, the monkey of the Western imagination at last managed to escape, at least in part, from all the negative personae forced upon it. From the unpleasant and vaguely scandalous mistake of nature of classical times to the embodiment of evil, sin, and waywardness of early Christian Europe, it ultimately transformed into a figure defined not by any of these negative qualities but by another, brighter one that had been secretly present in Western images of it all along: freedom.

This change can be seen in summary form by comparing two very different works by an artist whose life stands as a pivot between the Middle Ages and the Renaissance: Albrecht Dürer. In his famous early engraving *The Madonna with the Monkey* and his later drawing *The Monkey Dance*, this artist provides a vivid illustration of the distance separating the sin-encumbered monkey of ages past from the boisterous, comical rebel that it eventually grew into. In doing so he shows as well how this entire transformation subtly mirrors the changes that were unfolding within European society itself, as it slowly and painfully learned to regard the various constrictions and contradictions that played across it with a sense of humor.

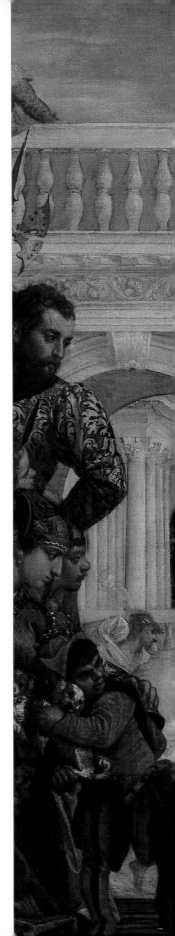

Paolo Veronese (c. 1528–1588). The Family of Darius before Alexander. *Like many another Renaissance artist, Veronese was fond of placing the occasional monkey in his sumptuous paintings, sometimes to suggest the exotic splendor of distant times and places, and sometimes to lighten the mood of a particularly dramatic scene. Symbolic intent was often present as well, and the fact that this monkey is conspicuously handling pearls and gold was probably intended to signify greed and dishonesty.* The Board of Trustees, The National Gallery, London.

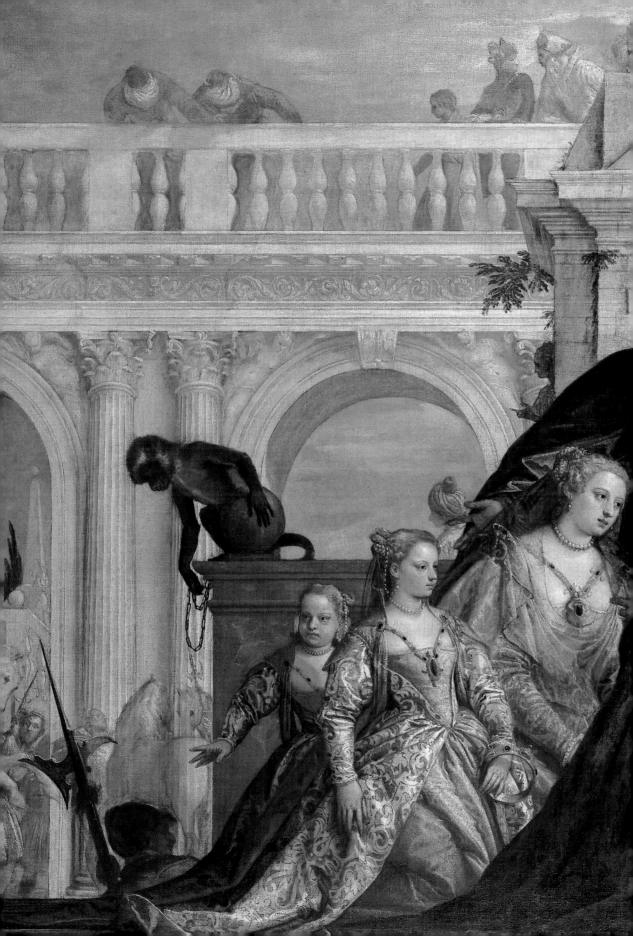

Like his near contemporary Pisanello, Dürer played a great part in initiating the unprecedented attention to physical detail so characteristic of Renaissance art. This new level of fidelity toward the things and creatures of the world combined, in his work, with a strong sensitivity for those creatures as living, feeling beings. Animals became individuals under Dürer's eyes: creatures with their own particular quirks and characteristics and their own particular charm or tragedy. So strongly conveyed were these qualities that they could, at least for a moment, actually free the animal in question from whatever stereotypical human attributes were customarily projected upon it.

In *The Madonna with the Monkey*, this new technical sensitivity to the living animal appears in a context that is still very much dictated by the symbolic concerns of the Middle Ages. The monkey sits seriously and a trifle malevolently at the foot of the Virgin in much the same manner as it had for so many artists over the course of the preceding centuries. Despite the keen objective skill with which this animal has here been rendered, it is clear that it is still being asked to serve as an emblem of sinfulness and vice—in this case, the state of primary sinfulness and vice that characterized all of Creation after the Fall and before Christ's redemptive appearance.

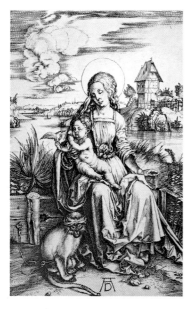

With *The Monkey Dance*, we move from the somber and serious to the comic, and with that movement we see the monkey abruptly relieved of the dead weight of centuries of sin and corruption, its essential monkey contrariness still intact but transformed now into a rebellious energy that is bright and gaily seductive instead of menacing.

Albrecht Dürer (1471–1528). The Madonna With the Monkey. Etching. The Monkey Dance. Pen drawing. Realism and comic anthropomorphism, religious symbolism and iconoclastic exuberance, are contrasted in these two works by the great German artist. In The Madonna With the Monkey, *the monkey depicted at the feet of the Virgin is thought to symbolize sin overcome. The festive figures in* The Monkey Dance, *on the other hand, embody a spirit of gaiety far removed from issues of sin and guilt.*

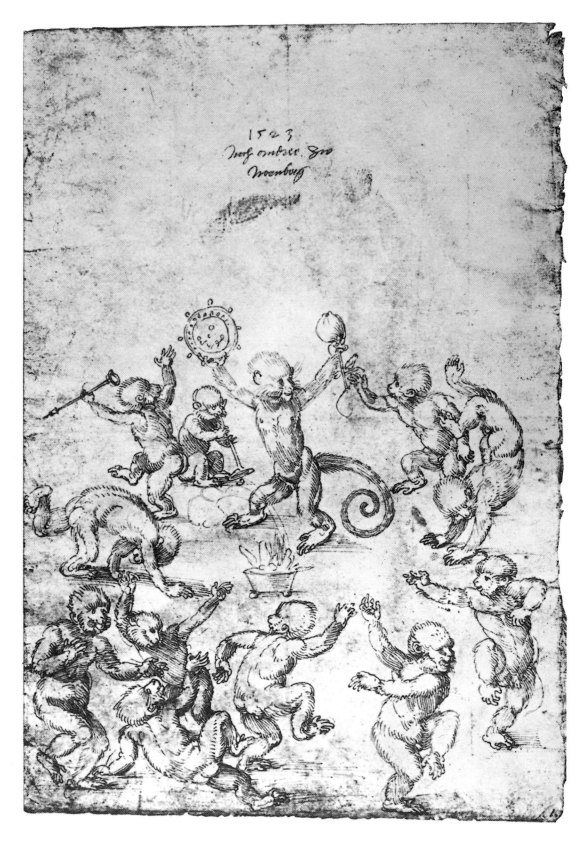

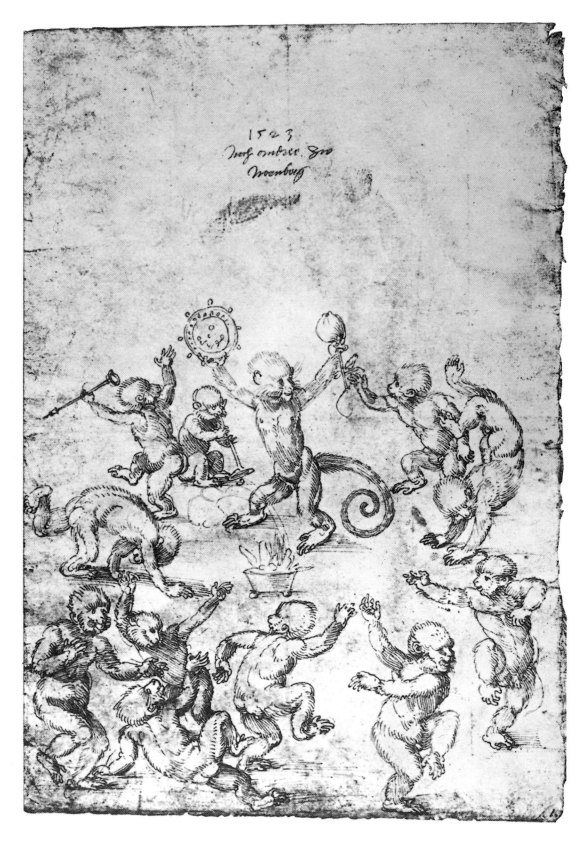

1523.

William Tons. Detail of tapestry. Monkeys playing with a panther. *According to the highly imaginative natural historians of classical antiquity, panthers lured monkeys down out of the trees by playing dead, then grabbed as many as they could when the monkeys succumbed to their curiosity. Though false, the idea was attractive to artists. Wawel Castle, Cracow, Poland.*
Erich Lessing/Art Resource, New York.

Beaker known as The Monkey Cup. *Silver, silver gilt, and painted enamel. Flemish, fifteenth century. The peddler and the apes theme found its way into a number of different mediums over the years. Here it decorates a fifteenth century beaker.*
The Metropolitan Museum of Art, New York. The Cloisters Collection, 1952. (52.50).

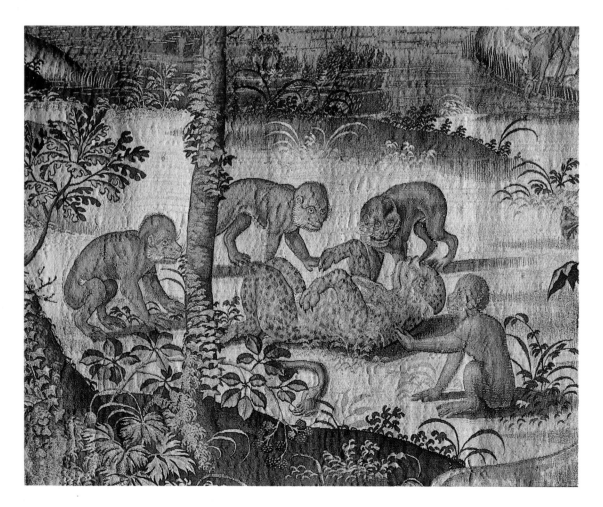

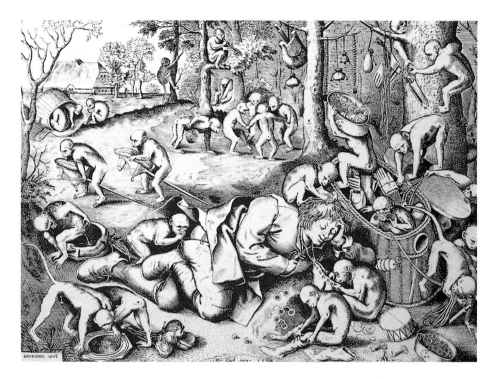

Pieter van der Heyden after Pieter Breughel the Elder. The Merchant Robbed by Monkeys. *Engraving. Sixteenth century. A typical example of the popular peddler and the apes theme, showing monkeys ransacking a traveling peddler who has either dozed off or perhaps had too much to drink. Though a number of moralizing interpretations were tacked on to such pictures, the theme was probably not originally intended to serve any lofty didactic purpose.*

Monkey and Hunter *from "Bestiaire d'Amour," illuminated manuscript from Northern Italy, first part of fourteenth century. Originally dreamed up in classical times, this scenario in which a hunter captures a monkey by tricking it into putting on a pair of lead-soled boots remained popular throughout the Middle Ages. The Pierpont Morgan Library, New York, M459, f.5v.*

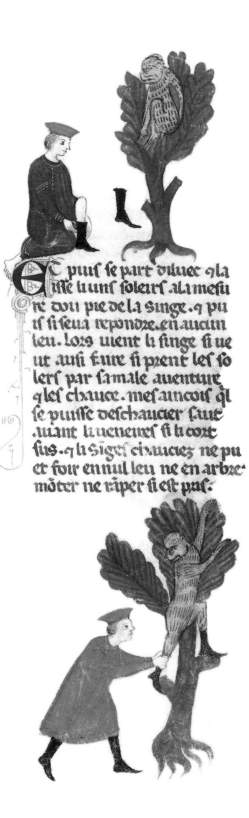

Et puis se part dinier q̃ la uisse li uns soiers ala mesu re dou pie de la singe. q pu is si seua reponore en aucun leu. lors uient li singe si ue ut auisi euire si pxent les so lers par sa male auenture q les chauce. mes aincois ql se puisse deschaucier saut auant li ueneres si li cort sus. q li singes enchauciez ne pu et foir en nul leu ne en arbre mõter ne riper si est pris.

The jubilant, somewhat anthropomorphic figures that dance and somersault around their suggestively long-tailed leader are the direct heirs of all those earlier, *drôlerie*-style monkeys that over the centuries had so diligently made mockeries of Christian Europe's most severe and sacrosanct institutions. Like them they seem to suggest that try as it might, the Christian West was not to escape the necessity of every now and then abandoning all its tensely guarded values and ideals and parading brazenly and nakedly around without them.

Whether celebrating or cursing it, whether depicting it in shackles or at loose among the treetops, European artists throughout the Middle Ages and beyond persistently chose to portray the monkey within situations of either conspicuous restraint or equally conspicuous freedom. Though those artists often may not have chosen to admit it, there was something in the irresponsible and freedom loving monkey that called forth a wistful admiration, and with the passing years the tendency to celebrate this aspect of the monkey's character instead of pretending to be appalled by it appears with increasing strength and frequency in European art.

If in the classical world to dress a monkey in the garments of a scholar or a politician served more to make fun of the monkey than the person who's clothes it was wearing, by the time of the Renaissance the situation had been rendered decidedly more ambiguous. In the course of its long career in Western art, the monkey had developed from a ludicrous approximation of humanity, funny in and of itself, into a mischievously liberated alter ego capable of seeing the flotsam and jetsam of human affairs with an appealingly unbiased eye. And in doing so it showed that even in its most pompous and contorted moments, European society was still capable of getting outside of and laughing at itself from a slight remove.

This use of monkeys not so much as targets for ridicule but rather as assistants in pointing up the assorted idiocies of human endeavor achieved a particularly quirky and vivid

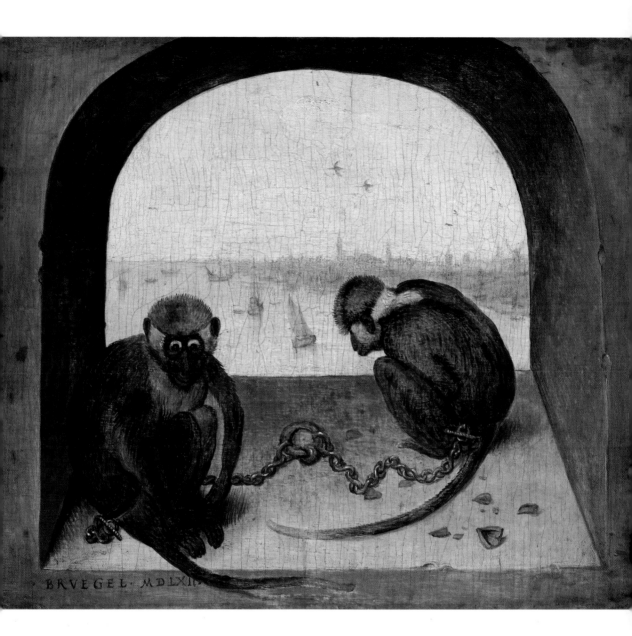

*Pieter Bruegel (c. 1525–1569). Two Monkeys. Wood panel. In this
treatment of the popular "chained ape" theme, compassion for the
monkeys in their cruel state of confinement takes precedence over the
usual symbolic associations. Symbolic undertones persist in Breughel's
painting, however, in the form of nutshells scattered at the unfortunate
monkeys' feet. The monkey's supposedly inordinate fondness for nuts
was read as evidence of its essentially base and fallen nature in the
Middle Ages, and the presence of nutshells here suggests that these
animals were intended to provide a lesson for humans.
Kunsthistorisches Museum, Vienna.*

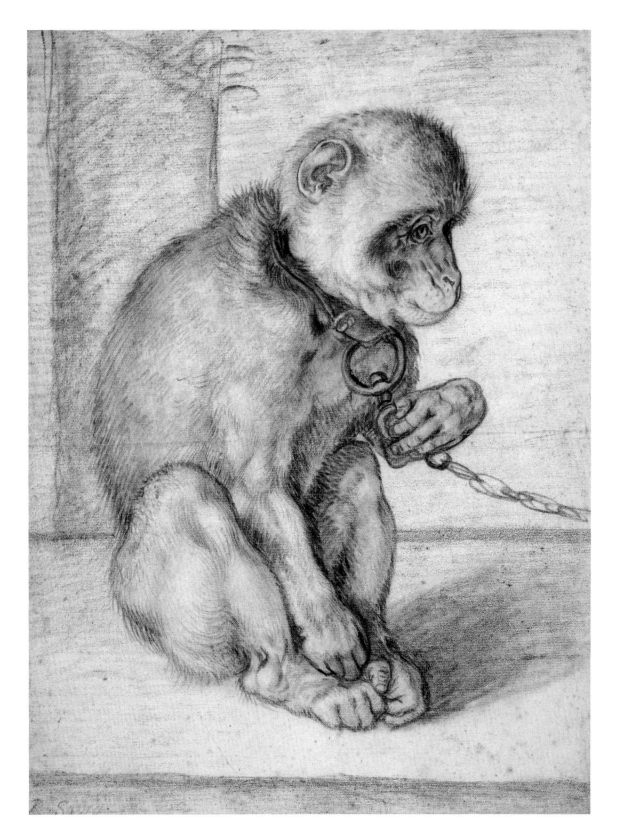

expression in a pictorial theme, popular from the fourteenth through the seventeenth centuries, in which a group of monkeys gather around the figure of a sleeping peddler. Probably appearing first within the margins of Gothic *drôlerie*, this theme is believed by Janson to have grown out of a legend of Greek origin purporting to describe the way monkeys were captured in the wild. According to this absurd but extremely long-lived theory, the hunter with monkeys on his list of captives enters the forest carrying a pair of lead-soled boots. Finding a conspicuous clearing, he sits down, puts on, and methodically laces up the extremely heavy boots with the hope that some monkeys might be watching from the trees beyond. He then removes the boots and departs, leaving them behind. Once out of sight he hides and waits, knowing that any monkeys present will not long be able to resist rushing out of hiding and indulging in their love of imitation. The first monkey to get to the boots and lace them up is then easily captured by the hunter.

This popular topic for marginal illustrations seems to have gradually evolved, along with several other equally far-fetched theories about methods of ape capture, into a scenario where the hunter, laden with the paraphernalia of his trade, falls asleep in the woods and is discovered by a troop of monkeys. At some point it was realized that even more comic possibilities could be gleaned by making the sleeping man a traveling salesman and thus weighed down with even more wares, all of which could be investigated by the monkeys with humorous results.

Here, as was so increasingly the case in the monkey's appearances in Western art from the Middle Ages on, the silliness of the situation disguises an interesting subversiveness at work there as well. By falling asleep in the woods with his bag of wares, the peddler effectively surrenders the trappings of European civilization to the inspection of a

Seated Monkey on Chain by Hendrick Goltzius (1558–1617). Previously attributed to Roelant Savery (1576-1639). Pencil drawing. Rijksmuseum, Amsterdam.

group of animals who represent the free, unhindered life of impulse. It is not just the uncultured monkeys who are being made fun of, nor the oblivious peddler, but more importantly the items themselves. As with the *drôleries*, the real brunt of the joke falls upon human beings and their various pursuits—here specifically their habit of manufacturing ridiculous gadgets. At the hands of the uncomprehending monkeys, far from the civilized world that gave birth to them, the assorted mirrors, compasses, telescopes, trousers, and snuffboxes are allowed to shine forth in all their essential silliness.

BELOW: *Franz Snyders (1579–1657).* Three Monkeys Stealing Fruit. *This Flemish artist's still lifes stand out for the lively animal figures. Attracted by the monkey's reputation for mischief, Snyders included a number of these animals in highly active poses in his works. Louvre, Paris. Photo R. M. N., Paris.*

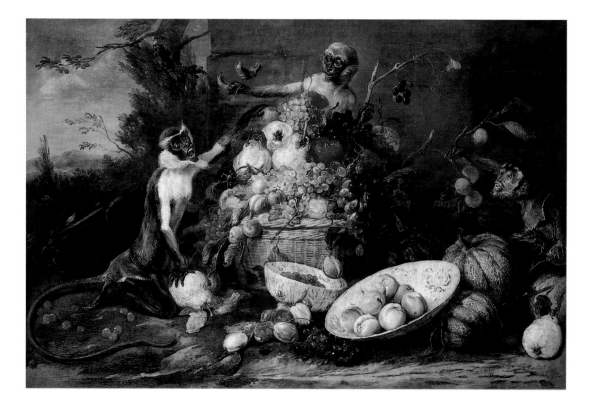

RIGHT: *Melchior d'Hondecoeter (1636–1695).* Peacocks. *This Dutch artist followed a long tradition in placing a monkey and peacock together. Sometimes used to suggest opulence and the exotic, the two animals could also symbolize certain negative human traits, such as appetite and vanity. The Metropolitan Museum of Art, New York. Gift of Samuel H. Kress, 1927 (27.250.1).*

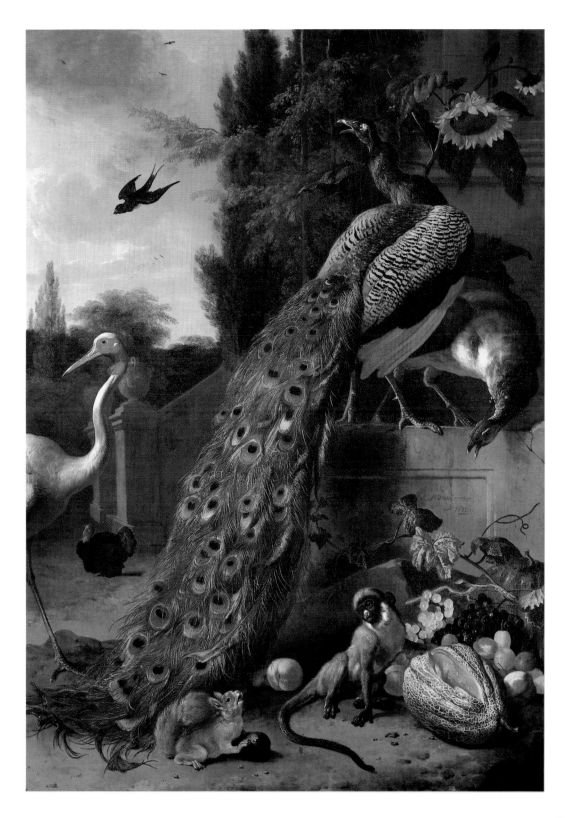

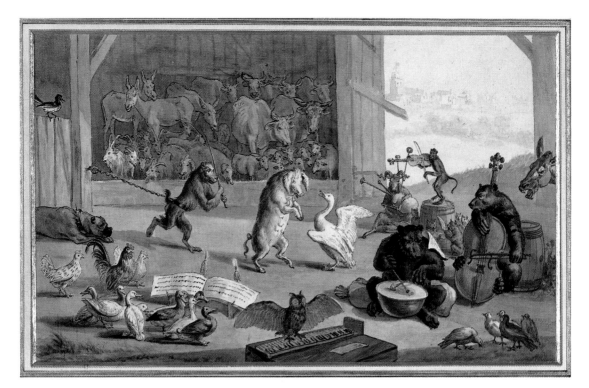

ABOVE: *Aert Schouman (1710–1792).* Animals at Carnival. *Watercolor.*
Accomplished in a wide variety of mediums, this Dutch artist was best known
for his watercolors featuring animals and birds. Here monkeys join an
exuberant group of animal celebrants for an informal concert and dance.
Courtesy Collection Galerie Palmieri, Geneva.

RIGHT: *Jan van Kessel (1626–1679).* Animals in a Landscape. *Van Kessel was*
one of a number of accomplished still life artists, Flemish and otherwise, with
a fondness for painting monkeys. Though known for the care and exactitude
with which he painted plants and animals, the artist has here allowed his
imagination fuller play.
Courtesy Collection Galerie Palmieri, Geneva.

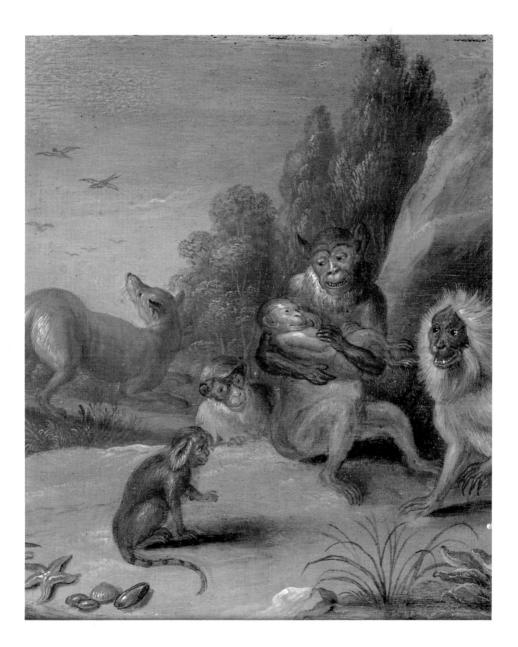

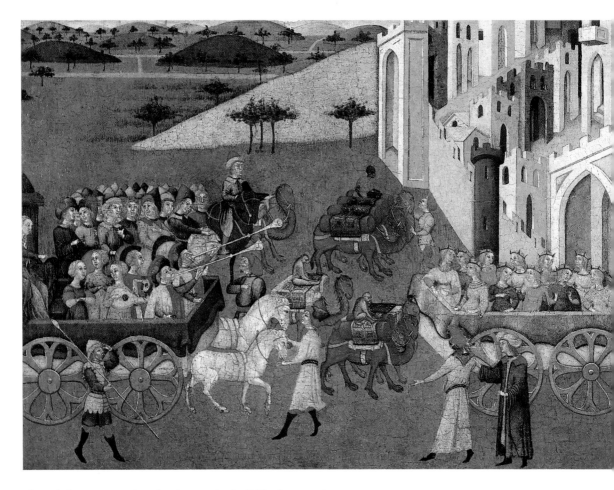

Though they are mentioned only once in the Bible, in a passing
reference to the wealth of Solomon in Kings, monkeys found their way
into artworks treating a number of biblical themes—particularly the
Garden of Eden in the medieval period and the Journey of the Magi in
the Renaissance. The cassone illustrates Solomon's visit to the Queen
of Sheba. In the Gentile da Fabriano painting, monkeys form part of
the three kings' entourage, and as such are treated to the same elegant
and meticulous presentation that the rest of the figures receive.

Cassone panel. Unknown Sienese painter, fifteenth century. King
Solomon and the Queen of Sheba.
The Metropolitan Museum of Art, New York, Rogers Fund, 1914 (14.44).

Gentile da Fabriano. (1370–1428) Detail of Adoration of the Magi.
Uffizi, Florence. Erich Lessing/Art Resource, New York.

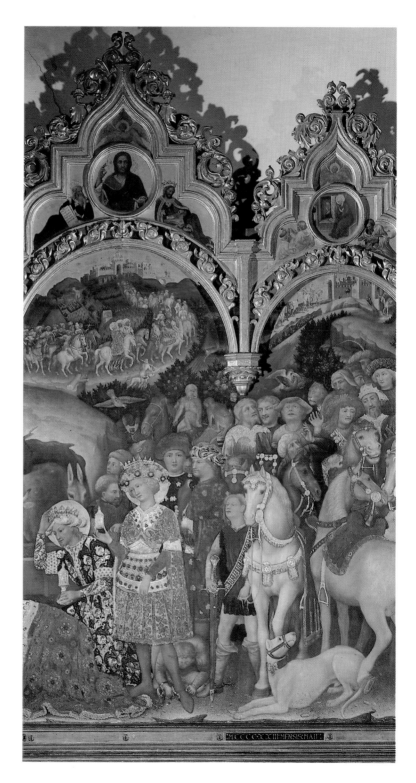

RIGHT: *Pierre Gobert (1666-1744).* Maria Anna of Bourbon with
Baby Trained Monkey. *Though miserably unsuited for the position,
monkeys sometimes served as status pets, especially in countries where
they were difficult to obtain. Uffizi, Florence. E. T. Archive, London.*

BELOW: *A pair of polychromed porcelain pilgrim bottles decorated with
medallions featuring monkey images after Franz Snyders. Worcester
Royal Porcelain Company, 1876.*
Private collection. Geneva.

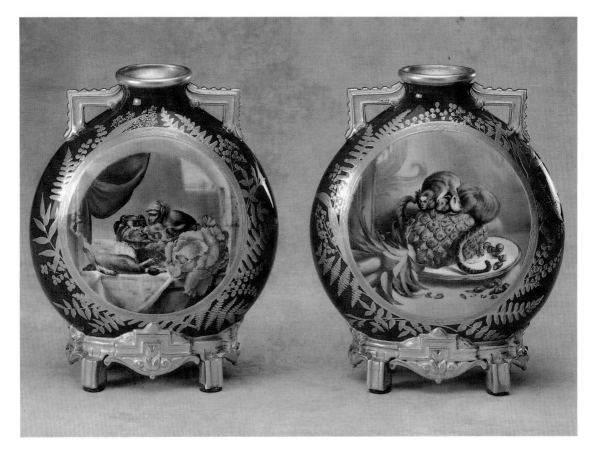

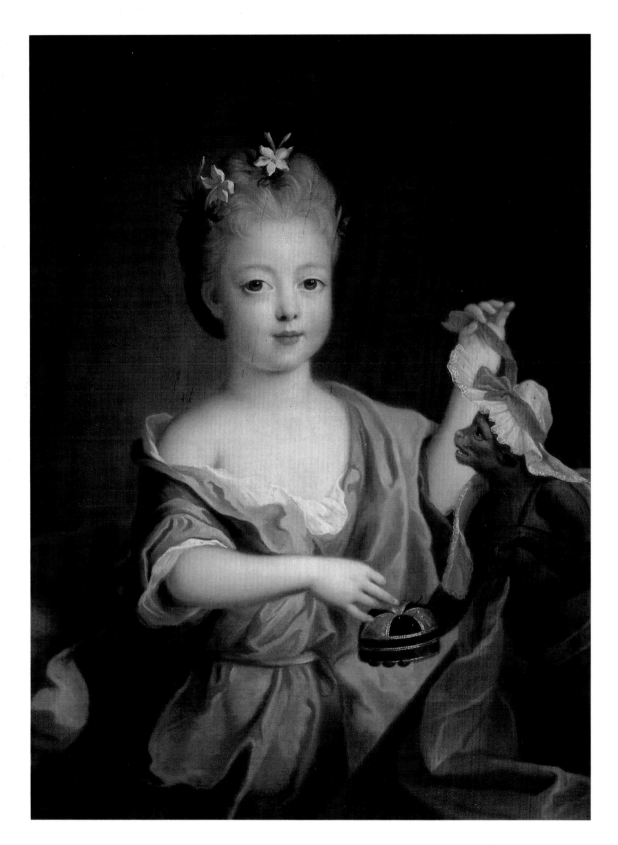

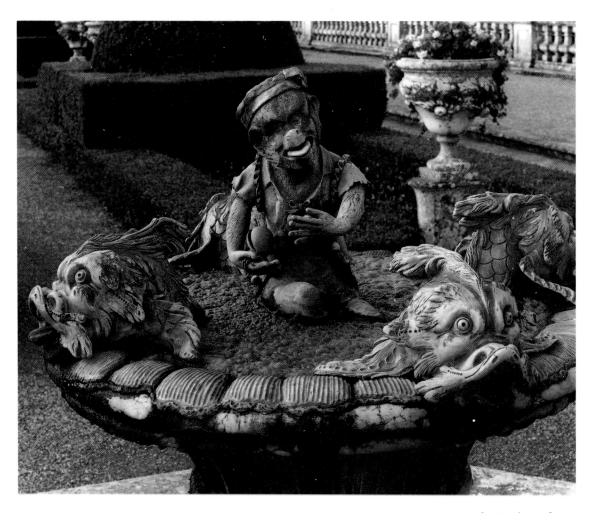

Fountains in the Gardens of
Queluz, Portugal. Created in the
mid-eighteenth century, these
curious lead seafaring monkeys,
with their castanets, three-
cornered hat and human clothes,
demonstrate French singerie's
quick and widespread influence
beyond France's borders.
Gardens of the Palace of Queluz,
Portugal.

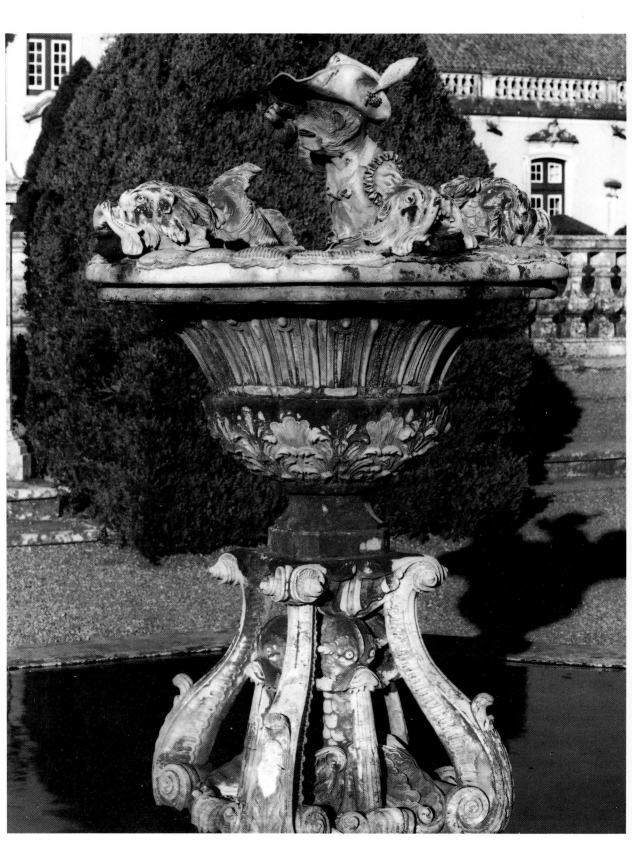

The Rococo and Singerie

In seventeenth-century Flanders, David Teniers the Younger, a prolific and accomplished master of the kind of subtle and unassuming everyday-life scene pioneered by Breughel, produced an extraordinary number of works featuring monkeys, not people, involved in similar pursuits. Teniers was not the first person to devote entire canvases to monkeys mocking human activities; growing directly out of Gothic *drôlerie*, the practice achieved a kind of official genre status during the Baroque, especially in Flanders. Nevertheless, Teniers stands out for the particular energy he devoted to the task. Few artists have spent more time depicting more monkeys going about more human activities than Teniers did, and few have succeeded in making the idea of creating such a burlesque in the first place seem so natural and felicitous.

It may have been the ease and self-assurance with which Teniers's simian creations carry out the dignified business of soldiers, schoolmasters, ministers, lawyers, and painters that recommended the monkey to the design painters of the French rococo a century or so later. The exact genealogy of the little monkeys that climb about the walls and ceilings of Christophe Huet's *Grande Singerie* at the château de Chantilly and other rococo masterpieces is, to quote art historian Dawn

Jacobsen, "something of a muddle." A probable line, however, can be traced from Huet back to Claud Audran, who placed monkeys in human dress in his work at the Chateau de Marly in 1709, and from there back to Jean Berain, who used monkeys within his classical grotesque designs a few decades before that.

Once established in France, the use of monkeys in decorative themes took on a curious cachet, and the practice spread rapidly and widely in the middle years of the eighteenth century. The seemingly unlikely prominence of the monkey in rococo art is at least partially explained by a quality of the monkey we have so far failed to mention: its exoticness. Perhaps simply by virtue of their being native only to lands far removed from Europe, monkeys could be enlisted, especially from the Renaissance on, as props to suggest the mystery of remote places and alien cultures. In pursuit of this effect, European painters attempting to capture the lush and languid courts of far-off kings and queens often included a stray monkey or two among the peacocks, pythons, and palm fronds typical of such scenes.

In the late seventeenth and early eighteenth century, Europe's fascination with China—or rather with the pleasantly hazy idea of it conveyed by the often less than reliable accounts of travelers there—gave birth to chinoiserie, a decorative style made up entirely of Western works created in what was imagined to be a Far Eastern style. Covering mediums from furniture to ceramics to paintings to entire garden layouts, chinoiserie is distinctive for its imaginative energy, its technical resourcefulness, and perhaps especially for the degree to which all of its various works fail to have anything much to do with the China of mundane reality.

It was probably thanks to its credentials as a genuinely exotic creature, combined with its satirical background in the works of Teniers and others of the Flemish school, that the monkey came to be seized upon by a number of prominent rococo artists and incorporated into their lavish chinoiserie decors. Whatever mix of circumstances was actually responsible for initiating these animals' entrance

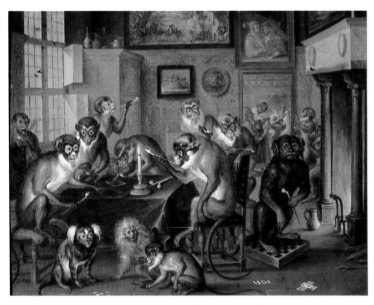

into the salons and châteaus of eighteenth-century France,
once there they managed to fit admirably into the spirit of
things. Whether one is charmed or irritated by rococo *sin-
gerie*, there is little question that the monkeys included there
fulfill the task assigned them as well as could be asked.

And that task, as it happens, is a decidedly familiar one:
the embodiment of freedom. Just as the romantic move-
ment had its bug-eyed, foaming-mouthed horses and its
roaring lions a century later, so the rococo used the monkey
to represent its own less imposing and more playful revolt
against the stifling pretensions and pomposities of the
Baroque. Whether clambering about the walls and ceilings
of a château in flowing Mandarin gowns or conversing
among each other in the garb of landed aristocrats, the fluid
little monkeys of the rococo served as the agents of a revolt
against former dictates and constraints that was itself more
than a little self-mocking. Like those curious and slightly
disdainful monkeys crowding in the branches above the
sleeping peddler, the creators of the rococo were out to up-
turn, and perhaps to playfully rearrange, the conventions of
the past, but not necessarily to destroy them or replace
them with some great and ponderous system of their own.
Casting about for a mascot in this enterprise, those artists

not so surprisingly hit upon the animal with the longest history of upturning and rearranging in all of Western art.

Without question, the artists of the West have often had trouble seeing monkeys as significant beings in and of themselves and have insisted instead on loading them down with an endless catalog of human qualities. Nevertheless, there is still much of value to be learned—about humans if not about actual monkeys—by looking at those projections. And if there is one consistent message that these monkeys of the imagination send down to us from the branches above—if one single lesson is to be gleaned from all the shamelessly irresponsible, cheerfully instinctive acts that they have been depicted performing over the centuries—it is of the possibility of freedom. For the monkeys of the ro-

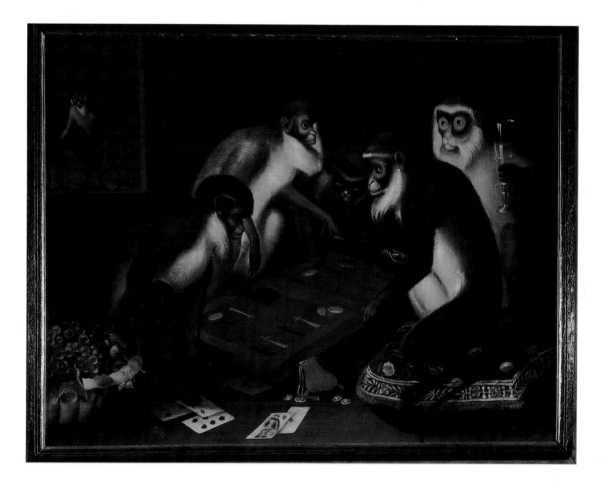

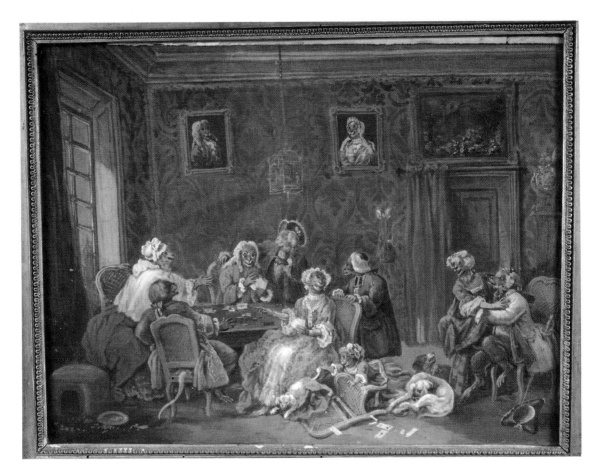

coco, as for Teniers's and those of the *drôleries* before them, all clothing is costume: to be worn for as long as it is entertaining and to be cast aside as soon as it ceases to be so. In the spirited reversals and abandonments that the monkey has again and again enacted, one finds evidence of a consistent affirmation of this attitude on the part of all the very different artists who created these images through the centuries. Ultimately, it is a sense that all costumes, no matter how heavy and elaborate, are removable; that whatever outfit one is called upon to walk through one's life wearing, it can, at least for a moment, be left triumphantly behind.

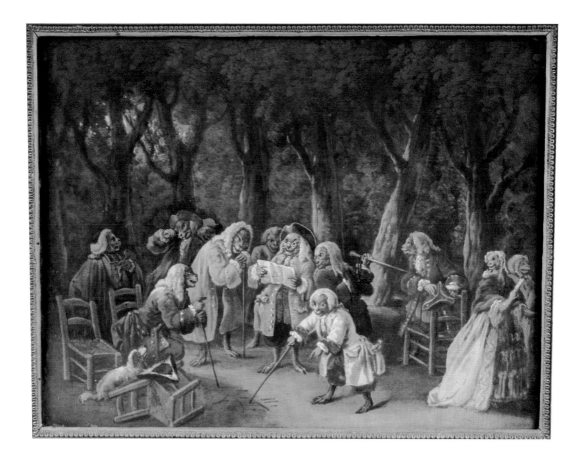

Alexis Peyrotte, eighteenth century. The Politicians at the Tuileries Gardens *and* The Card Game. *Gouaches. Peyrotte, who often collaborated with Huet, shared his affection for monkeys as tools for parodying eighteenth-century France's social and political conventions. Musée de Carpentras, France. Photos Archive de Carpentras.*

Painted in 1735 for the Duke of Bourbon, Louis-Henri de Condé, at the château de Chantilly, Christophe Huet's Grande and Petite Singeries are acknowledged masterpieces of the genre. The images of the Grande Singerie decorate one of a series of highly ornate reception rooms at the palace, and feature a number of monkeys, outfitted largely in mandarin gowns, engaged in various satirical activities.

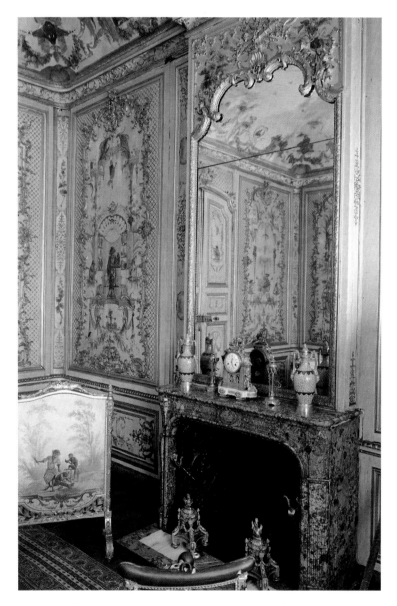

Detail of silk fire screen.

Partial view of the Grande Singerie.

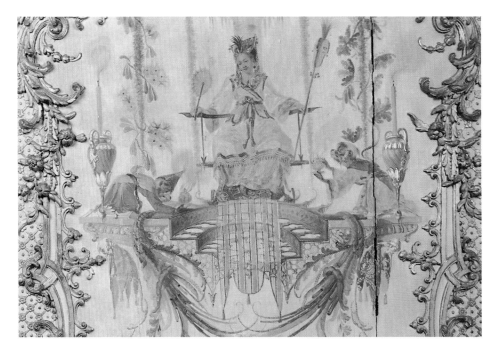

On one of the Grande Singerie panels, Huet's debt to
Antonine Watteau is playfully acknowledged by a reference to
that artist's famous painting of the Chinese goddess Ki Mao
Sao. The situation of that painting is repeated here, with
monkeys filling the role of the goddess' worshippers, and a
conspicuously contemporary Frenchwoman appearing as the
goddess. The activities are all enclosed in intricate rococo-style
paneling framed in gilded boisserie, the action continuing on
the doors, the ceiling, and even the furniture.

Monkey offering a caper. The whimsically warped visions of
China produced by rococo artists often featured scenes
showing exotic goddesses being worshipped by fancifully
dressed Chinese attendants. Like the figures in the Ki Mao Sao
panel, this monkey seems to be mocking situations of
subservience in general.

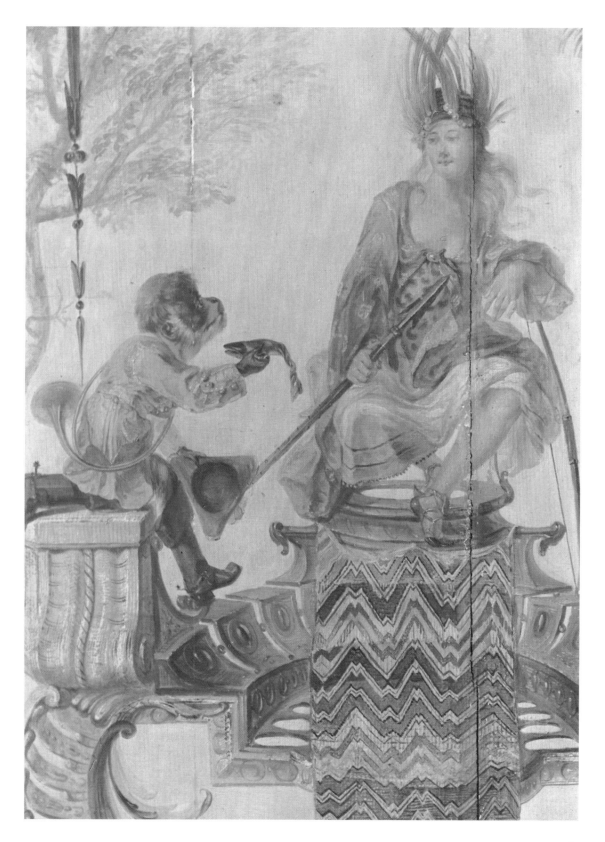

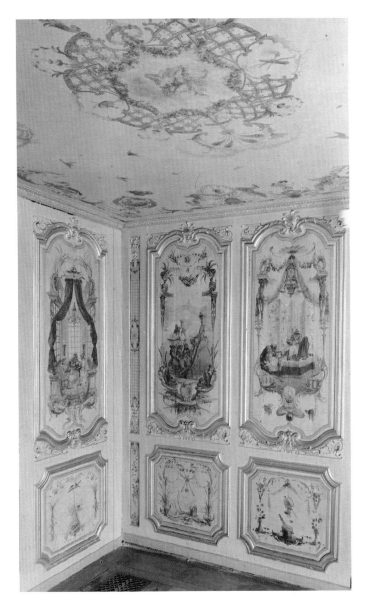

Though less famous than the Grande Singerie, the paintings of
the Petite Singerie, which fill one of a series of small salons in
the private section of the chateau, are equally accomplished.
Unlike their mandarin counterparts in the Grande Singerie,
these monkeys are outfitted in assorted eighteenth-century French
costumes and are engaged in spirited imitation of everyday
activities.

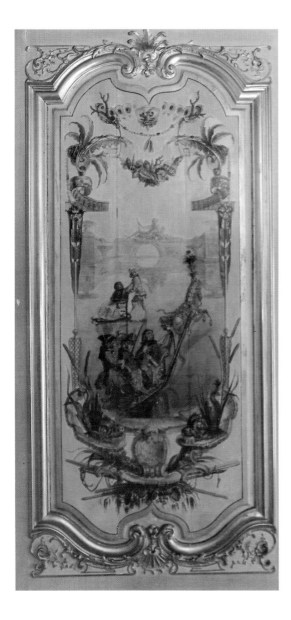
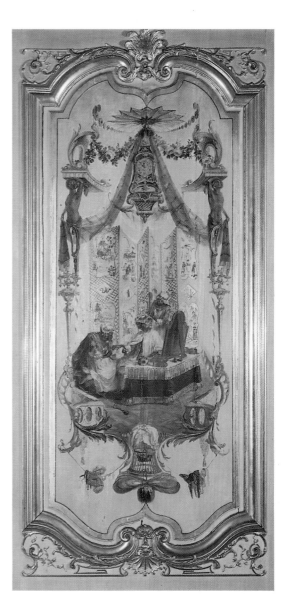

Three panels from the Petite Singerie *at the château Chantilly.*
A rosette with a floral pattern is visible on the ceiling. On the walls,
framed with gilded boisserie, are the panels showing "The Card
Game," "The Promenade on Ice," and "The Toilette." Below the
dado, the room is further enlivened by colorful wainscoting.

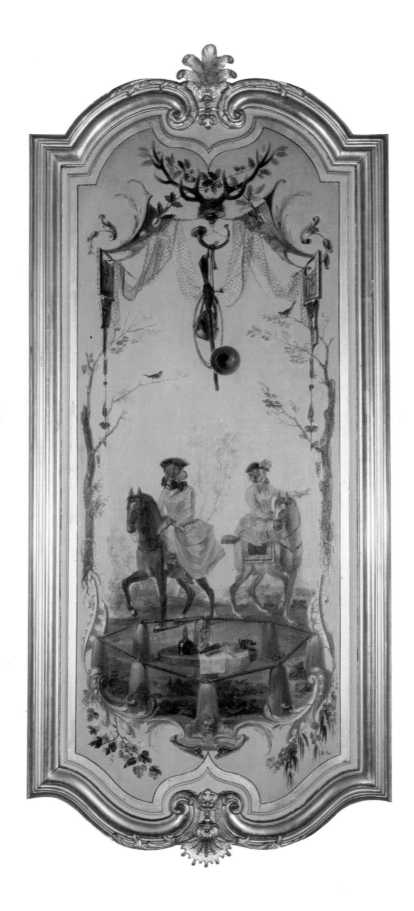

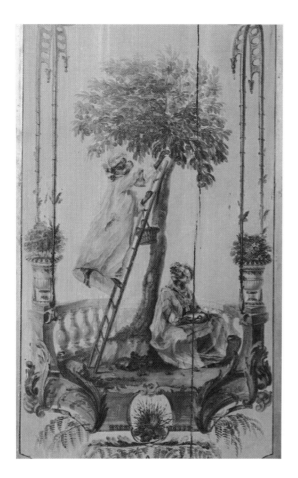

A pair of elegant eighteenth century monkeys on horseback from the Petite Singerie.

Cherry Picking.

The Bath.

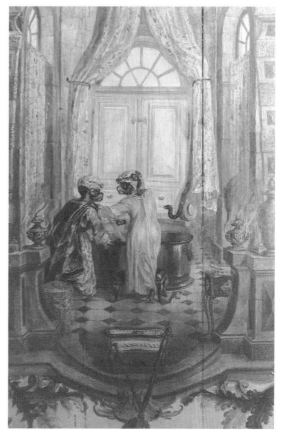

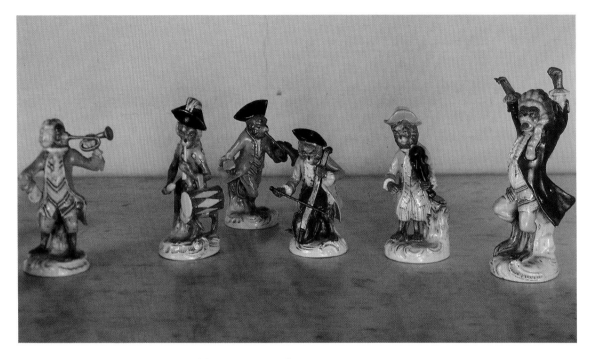

Located near Dresden in the town of the same name, the Meissen
Porcelain Manufactory was founded in 1710 and was for a time the
undisputed leader in the production of fine porcelain. The factory
enjoyed its greatest creative peak in the middle of the eighteenth
century, at the same time that rococo was at its height. Meissen's
tremendous success is chiefly attributable to the discovery of hard-paste
porcelain by its first director, Johann Friedrich Böttger. The delicacy
and liveliness achieved through this method is well displayed in the
numerous rococo, singerie-style monkeys that appeared in Meissen
designs over the years. In 1753 Madame de Pompadour purchased a set
of nineteen of these orchestral figures, which were probably based
roughly on the monkeys at the château de Chantilly.

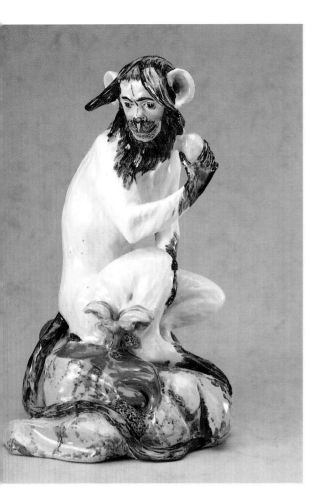

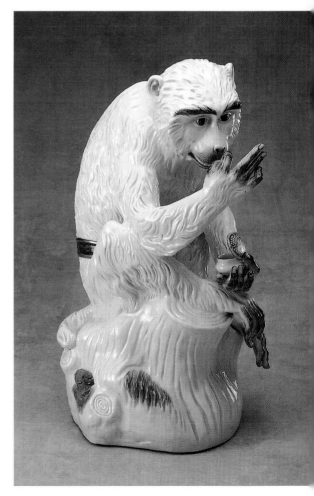

*Meissen musicians: from left, trumpet, drum, horn,
bass fiddle, violin. Conductor on far right.
Private collection, Florence.*

*A polychromed seated ape snuffing, and a highly
anthropomorphic "ape" holding a fruit, modeled at
Meissen around 1735, both modeled by Johann
Gottlieb Kirchner.
Courtesy Collection Galerie Palmieri, Geneva.*

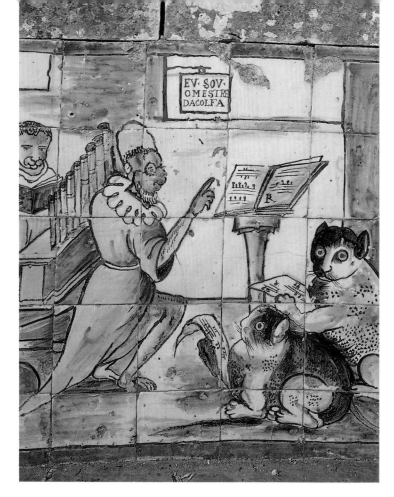

Two details from the garden
bench at Fronteira: A Monkey
conducting an orchestra and a
Monkey giving a cat a pedicure.
Monkeys and cats are frequently
paired in European art from the
Middle Ages onward. This
unlikely partnership appears in
ancient Greece as well, and
seems to be the result of the
female cat's long-standing
reputation for wantoness.
Teniers paired cats and monkeys
often, and in the eighteenth
century the practice was taken
up by Portugal's tile makers in
their singerie-style tile works.

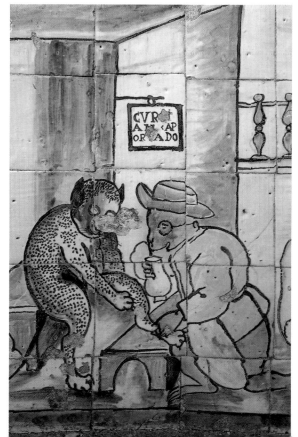

The burst of economic prosperity that Portugal enjoyed as a result of its colonial ventures led to a corresponding surge of interest in the arts. French chinoiserie was one of the exotic styles taken up by the Portuguese, who incorporated it into the versatile and durable azulejos, or earthenware tiles, they favored as indoor and outdoor wall decorations. Portuguese singerie was often more pointedly—and even rudely—satirical than its French equivalent, its chief target being the Spanish.

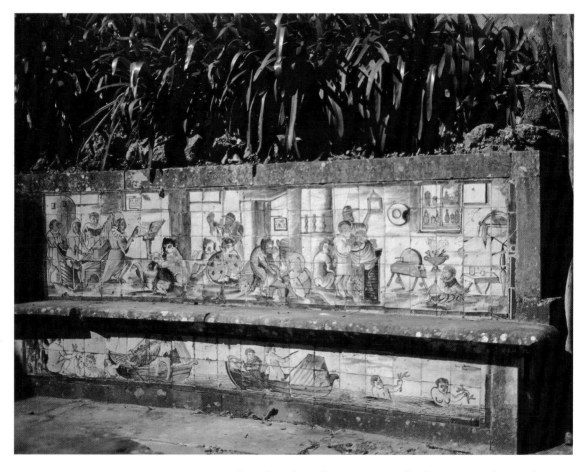

Bench in the Palacio de Fronteira garden featuring monkeys and cats engaged in a series of activities. Palacio de Fronteira, Belem, Portugal. Courtesy of Fundação das Casas de Fronteira e Alorna.

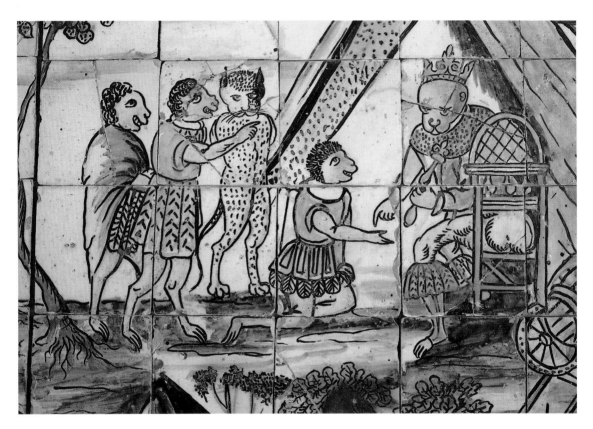

*Detail from a tile panel showing a monkey in the costume of a Spanish
king. O'Solar, Lisbon Portugal.*

RIGHT: *Blue and white details of tile decorations in the Palacio de
Fronteira garden.*
Courtesy of Fundação das Casas de Fronteira e Alorna.

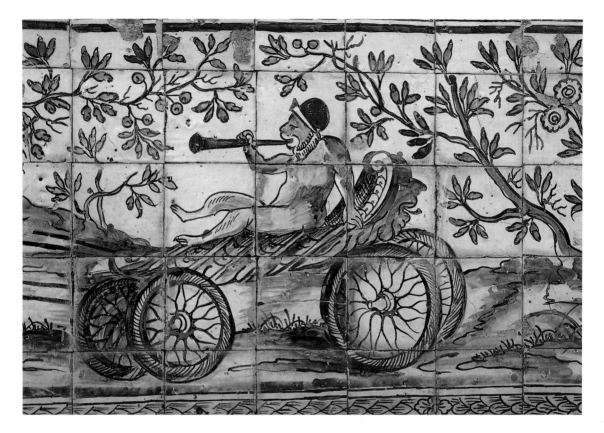

India and Hanuman

Such, more or less, has been the career of the monkey in the art of the West: a career that began with the attentive and reverential works of ancient Egypt and Minoan Crete, degenerated into mockery and even fear in classical and medieval times, and culminated in the essentially positive, comic incarnations that most define the place of this animal in Western art from the Renaissance up to today. Elsewhere, outside the reach of both the Greco-Roman and Judeo-Christian traditions, the monkey has had a better time of it entirely—though it still hasn't remained immune from lower characterizations.

Probably nowhere else in the world have monkeys and humans enjoyed such a long and intimate relationship as they have in India. For century upon century, India's towns and villages have played host to troops of monkeys that move in and out of fields, streets, and buildings with a casualness equaled only by pigeons in the towns and cities of the West. Taking advantage of their sacred status in Indian religion, these monkeys have different patterns of behavior than India's truly wild monkey troops, which choose to make their living without human help and never venture into villages or towns for handouts. Until increasing urbanization began disrupting it, this arrangement between humans and monkeys served both sides well. Though responsible for inevitable disruptions and inconveniences, and a strain in seasons of hunger because of their persistent food theft, these semi civilized monkey troops served as intermediaries between the world of humans and the world of nature, helping to keep the lines between the two from ever being too firmly or proudly drawn.

Much of the veneration—or at least tolerance—given the monkeys who loiter about the villages and cities of India results from their association with the Indian monkey god Hanuman. Said by some to be the most popular of all

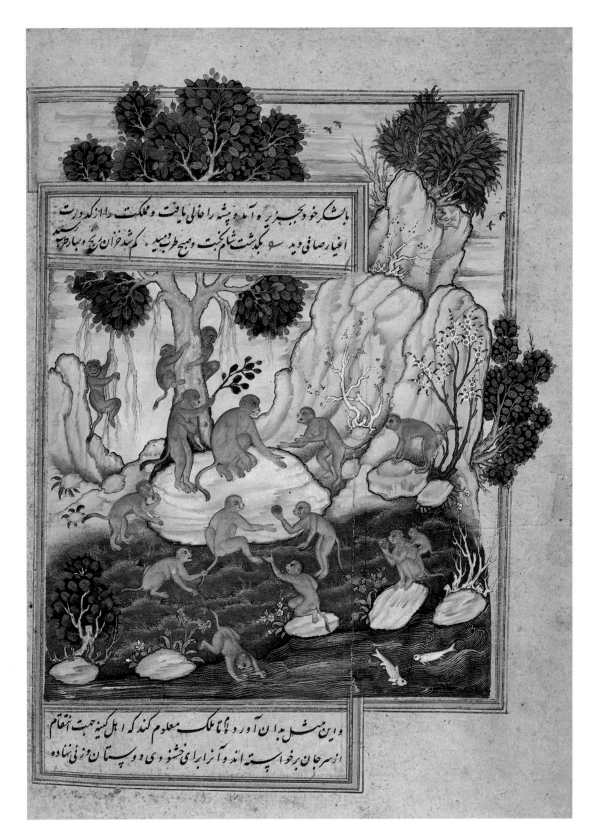

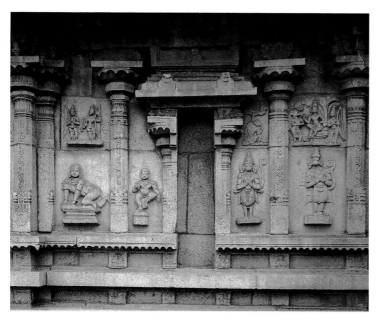

Details of Temple at Vijayanagara. India has invited animal figures into its religious structures with a consistency and generosity unequaled by any other country. Monkeys—single, in pairs, and sometimes forming enormous crowds—join other highly regarded animals like elephants and serpents in countless temples there. Photos Kea/London.

Indian deities, Hanuman is the champion and ultimate embodiment of what would seem a very unmonkeylike quality: obedience. Hanuman is such a persistently obedient deity, appearing so often in one or another posture of submission, that for a Westerner it is hard to understand why anyone would have envisioned such a god in the form of a monkey in the first place. The people of India know as well as anyone else that monkeys are not especially obedient creatures, and it may have been that in making this most unswervingly reverential god in the form of a monkey they were seeking to make a fairly direct statement about the importance and the universality of the attitude of submission—specifically, submission in the face of the divine.

Though Hanuman himself—and the general reverence for monkeys that he inspires—is much older than the *Ramayana*, the large part he plays in this national epic has been the chief reason for his massive and widespread popularity. Across India and throughout Southeast Asia, Hanuman's exploits are known in detail and frequently depicted in art and drama. His ubiquitous image appears in a wide range of forms, from delicate paintings to statues to the intricate leather puppets used in Asia's popular shadow plays, of which scenes from the *Ramayana* are a favorite subject.

Hanuman's role in the long, tumultuous plot centers around his relationship to the blue-skinned god Rama, who, along with his long-suffering and ever-imperiled wife, Sita, is the hero of the story. Hanuman's skills and abilities know no bounds: In addition to being a capable warrior, politician, dancer, and master of such various and unlikely academic disciplines as grammar and rhetoric, he is gifted with immortality, the ability to instantly shrink or grow to whatever size he likes, and to soar through the air without wings. R. K. Narayan, the author of one of the more streamlined English versions of this epic, writes there that:

> Hanuman is said to be present wherever Rama's name is even whispered. At a corner of any hall, unnoticed, he would be present whenever the story of Rama is narrated to an assembly. He can never tire of hearing about Rama, his mind having no room for any other object. The traditional narrator, at the beginning, will always pay a tribute to the unseen Hanuman, the god who had compressed within himself so much power, wisdom, and piety.

Along with his role in the retellings of the *Ramayana* that are always taking place throughout India and far beyond its borders, Hanuman plays an important part in day-to-day life as the guardian of villages, and few in India are without an image of him, typically in stone.

Standing Hanuman. *Bronze. Tamil Nadu, Tanjore region. Chola period, eleventh century. Though Indian art is rich in realistic monkey images, those of the monkey general Hanuman often tend toward the anthropomorphic. This elegant Chola bronze follows the common practice of representing him in human form, with the exception of the face and the prominent, simian tail.*

The Metropolitan Museum of Art, New York (1982.220.9).
Purchase, Bequests of Mary Clarke Thompson, Fanny Shapiro, Susan Dwight Bliss, Isaac D. Fletcher, William Gedney Beatty, John L. Cadwalader and Kate Read Blacque, by exchange; Gifts of Mrs. Samuel T. Peters, Ida H. Ogilvie, Samuel T. Peters and H. R. Bishop, F. C. Bishop and O. M. Bishop, by exchange; Rogers, Seymour and Fletcher Funds, by exchange; and other gifts, funds and bequests from various donors, by exchange, 1982.

If there is one central moral to be gleaned from the countless cosmic battles, betrayals, and intrigues that fill the "Ramayana," it is that unflinching loyalty—be it to parents, friends, or the gods—is the first of duties, to be shirked only at great personal peril. As the supreme embodiment of this quality, Hanuman is in a sense the story's most consequential character, for he sets the example of devotion for all humanity to follow.

RIGHT: *Attributed to Danaku of Guler. The Spies Suka and Sarana are discovered by Vibishana. From an illustrated manuscript depicting the* Siege of Lanka *from the "Ramayana." India, Punjab Hills, Guler, about 1725. Museum of Fine Arts, Boston. Ross-Coomaraswamy Collection.*

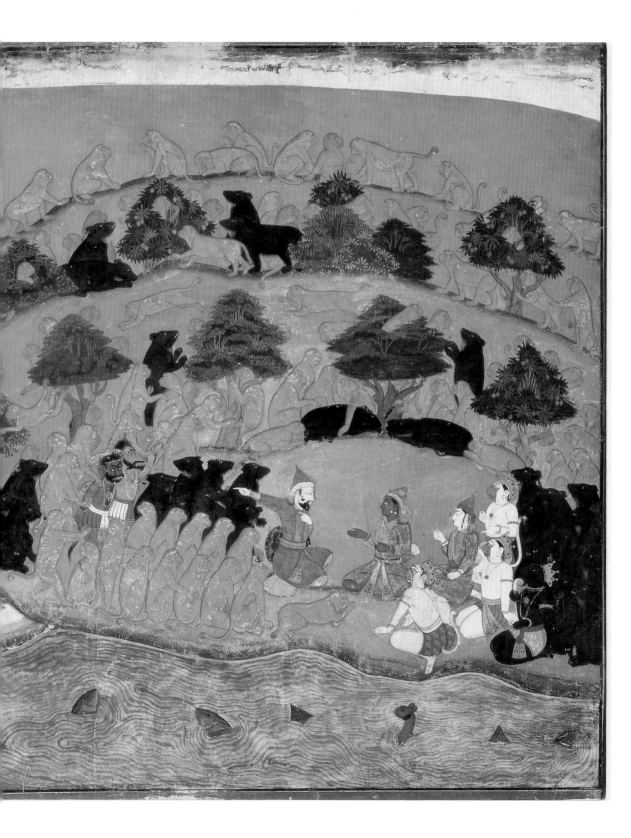

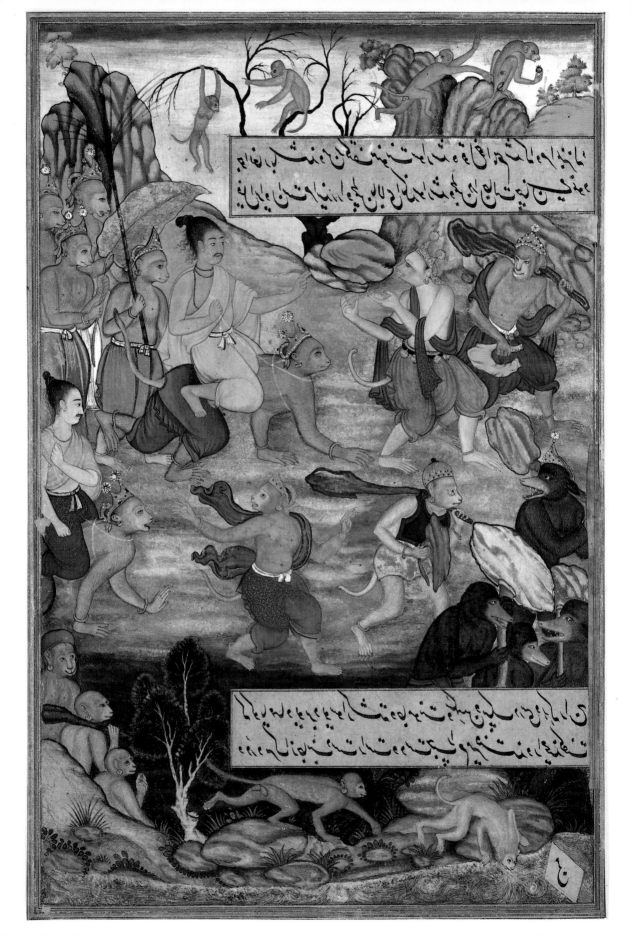

Rama Riding Piggyback on Hanuman. *Imperial Moghal school. From a manuscript of the "Ramayana" commissioned by the Moghal Emperor Akbar as a gift to his mother. Dated 1593. Courtesy Cynthia Hazen Polsky Collection, New York.*

Though central to its plot, Hanuman is by no means the only monkey featured in the "Ramayana." In the course of Rama's quest to recover his wife, Sita, from the lascivious, ten-headed archdemon Ravana—a task that takes up the majority of the epic—he is aided by no less than an entire army of monkeys. These are recruited from the jungle city of Kiskinda, a monkey metropolis ruled over by the monkey king Sugreeva, to whom Hanuman acts as friend and military adviser. Rama stumbles upon Kiskinda midway through the epic, and from then on the city's talented inhabitants appear at virtually every turn of the story. This accounts in large part for the remarkably high number of monkeys found in Indian art, for the Ramayana has long been one of the most popular topics for Indian artists.

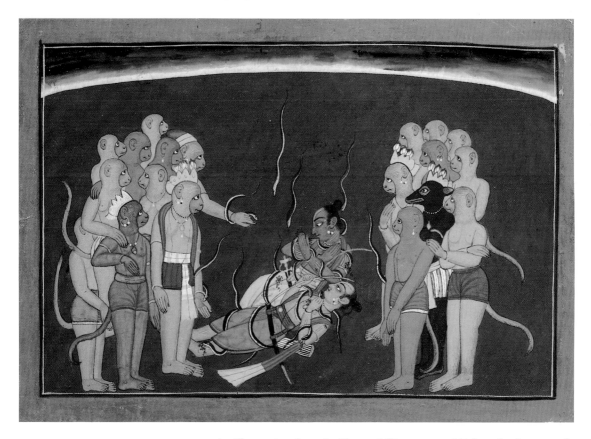

An illustration from the Shangri "Ramayana." Bahu school, c. 1700. In this early-eighteenth-century illustration, Rama and his brother Lakshmana lie in the coils of magical serpents sent by Ravana as Hanuman and a number of Kiskinda's other monkey inhabitants look on in dismay. Courtesy Cynthia Hazen Polsky Collection, New York.

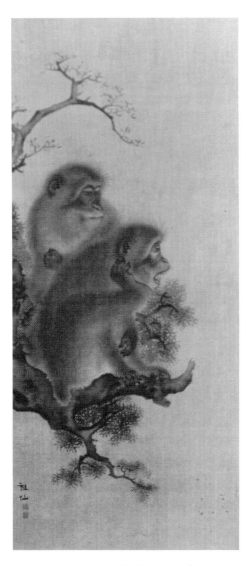

Mori Sosen (1749–1821). Two Monkeys.
Private collection.

Japan and The Monkey Performance

Perhaps because of the resemblance of some species to old, bearded men, the monkey in Eastern countries sometimes enjoys a reputation for wisdom that once again stands in direct contrast to the image of the fool it so often carries in Western traditions. In certain parts of the South Pacific the ancestral spirits are believed to take the form of monkeys, and in Thailand the Buddha himself is said to have incarnated as a monkey eleven times. One of the longest-lived subjects for popular artworks, and one still commonly produced today, are Mizaru, Kikarazu, and Irawazu, the three monkeys of Japanese Buddhist origin whose hands cover eyes, ears, and mouth to suggest the Buddhist prescription of applied disinterest in the affairs of the world.

Japan is also the home of a very old performance tradition, with its roots deep in the shamanic worldview of this country's ancient inhabitants, in which a monkey dresses in human garb and engages in various comic activities. The scenarios usually center around issues relating to the complex Japanese social hierarchy, and in times past they could be quite daring, with the monkey performers going through routines that made fun of the upper levels of society in a most pointed fashion.

The history of these performances is long and complex. They began not as entertainment but as a form of magical, essentially shamanic healing in which the dancing monkey acted as the emissary of the Mountain Deity, an old and venerable god from the extensive pantheon of the ancient Japanese religion of Shinto. Monkeys and horses were believed to enjoy an intricate relationship in ancient Japan, and the performance originally evolved out of a ritual for curing sick horses in which the trained monkey, by dancing

in the horse's vicinity, helped to drive out the spiritual agencies that were making it ill. Over time this original context was lost and the dance evolved into an elaborate comic routine performed before the general public.

Issues of identity—both individual and national—have long played an intensely important part in Japan's history, and as a result its arts have spent much time questioning and commenting upon the barriers separating class from class and country from country. The line dividing animals from humans is one of the first and most obvious demarcations the world presents to us, and many of the cultural boundaries created by humans over the centuries developed as logical inferences from it. Monkeys, of course, violate this line completely, and it thus makes perfect sense that a country as traditionally concerned with boundaries of one sort or another would have seized upon the monkey as the ideal figure to explore and comment upon the tensions those boundaries create.

In addition to a number of striking artistic representations of the monkey performance, the monkey's role as a satirist of human affairs is preserved in Japanese art on the well-known *Chōjū Jumbutsu Giga*, or "scrolls of frolicking animals and people." Dating from the twelfth century, these technically brilliant paintings present a variety of animals, including frogs, monkeys, and others, spiritedly going through assorted human cultural routines in a way that reminds one in content—if not in style—of the *drôleries* of the West. Monkeys both serious and satirical have consistently appeared in Japanese art up to the present, one of the most admired recent painters of them being the nineteenth-century artist Mori Sosen.

Sobum, Monkeys Swinging
From Tree to Grab an
Octopus. *Watercolor.*
Victoria and Albert Museum,
London. E. T. Archive/London.

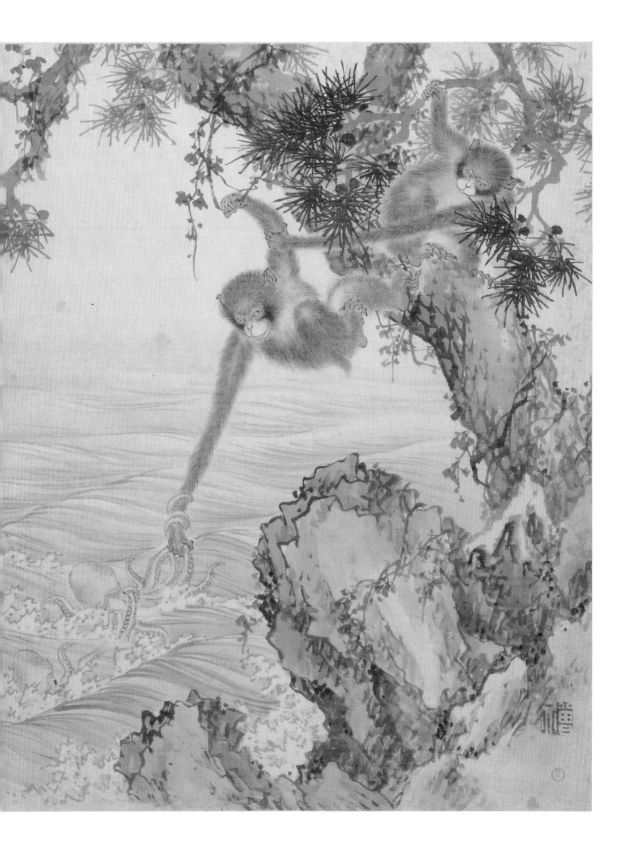

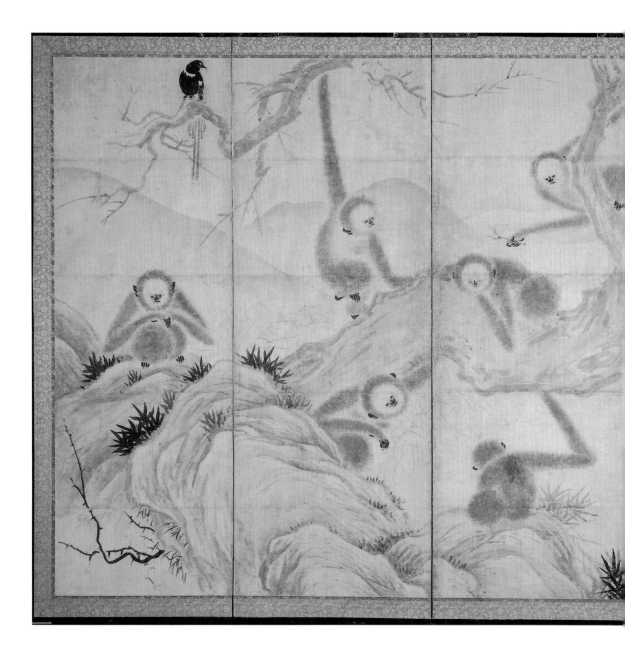

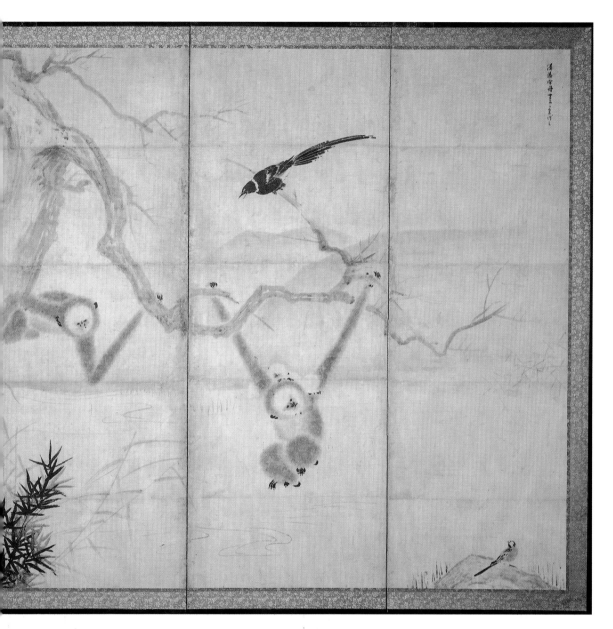

Attributed to Sesshu Toyo (1420–1506) Monkeys and Birds in Trees.
Japan, Muromachi period, dated 1491. Six-panel folding screen, ink on
paper. . Though not native to Japan, gibbons have long been a popular
subject for Japanese artists, who based their images of this animal on
works imported from China.
Museum of Fine Arts, Boston. Fenollosa-Weld Collection.

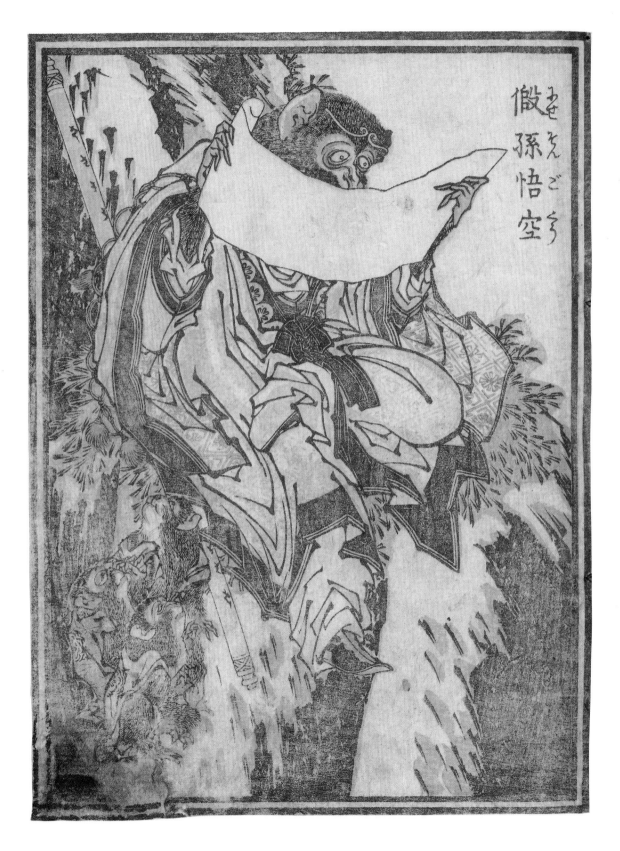

擬孫悟空

China—The Monkey As Sage

If the widespread presence of monkeys in Indian art has much to do with Hanuman and the *Ramayana*, a similar connection can be made between the equally rich store of monkeys found in Chinese art and another epic tale. The Buddhist/Taoist flavored *Journey to the West*, also known as *Monkey*, is generally agreed to be the most popular work of fiction in the history of China, and its hero, Monkey, thus probably bears the distinction of being the most important simian character in all of literature. Born miraculously at the top of a mountain from a giant stone egg impregnated by the forces of Heaven, Monkey undergoes an elaborate series of adventures in the course of his search for ultimate enlightenment. His quest leads him, after eventful passages through a number of bizarre mythological realms, to India, where he assists his human companion, the monk Hsuan-tsang, in the collection of Buddhist documents to help further the spread of this teaching in China.

Illustration from Journey to the West.
Harvard-Yenching Library ,
Harvard University, Cambridge,
Massachusetts.

Long and outlandish, *The Journey to the West* is distantly patterned on the adventures of the historical Hsuan-tsang, a seventh-century Chinese monk who did in fact undertake a dangerous trek to India to secure Buddhist teachings. Over centuries of retelling, Hsuan-tsang's story gradually took on an enormous catalog of folklorist and philosophical embellishments, eventually evolving into the litany of fantastic supernatural trials and adventures, lengthy philosophical and metaphysical speeches, and simple humor that it is today. *Monkey* has long been popular with artists and illustrators, most of whose work features its simian hero engaged in battle or discussion with the various animal, human, and superhuman characters he meets along his way.

One of the biggest mysteries of the transformation of Hsuan-tsang's real-life adventures into a tale revolving around a semi-divine monkey is how the character of Monkey himself entered into the story, and how he came to

take on such a central role in its plot. The answer seems to have something to do with the winning combination of opposing qualities that the figure of Monkey is able to accommodate. Bumbling and obnoxious, yet at the same time discerning and humble, Monkey manages to incorporate within himself both the unspeakable folly and the potential grandeur of the human condition—a grandeur that in the Buddhist-infected milieu of *The Journey to the West* is directly related to the condition of ultimate enlightenment that Buddhism believes to be the true goal of human existence.

East and West, monkeys have often been humorously portrayed as animals who act in a grander manner than their fellow animals because they labor under the delusion that they are actually human beings. Also in both East and West, this foolish presumption was sometimes read as an image of humankind's perhaps equally deluded ideas about itself.

Yi Yuan-ji. Monkey and Cats. *Sung Dynasty, eleventh century. Handscroll, ink and color on silk. Though known for his gibbons, Yi Yuan-ji is credited with paintings featuring other simians as well, such as this one of a monkey clutching a stolen kitten. The monkey's love for the young of other creatures is a mysteriously widespread piece of simian lore, though it seems to have no great basis in reality. National Palace Museum, Taipei, Taiwan, Republic of China.*

Mu-hsi. Mother Gibbon With Her Baby. *Ink on Silk. Daitoku-ji, Kyoto. Thirteenth century. This most famous Chinese gibbon painting is part of a tryptich featuring the goddess Kuan Yin, whose image is as common in the Buddhist temples of the Far East as that of the Virgin is in the churches of the West.*

Where the monkey saw itself as a human, humans could see themselves as superhuman gods or angels, thereby setting themselves up for a similarly cruel disappointment. By casting a monkey in its leading role, the authors of *The Journey to the West* were perhaps suggesting that this kind of absurd presumption was not always such a bad thing, for it was only by aspiring impossibly beyond oneself that spiritual progress was to be made. By being so thoroughly ridden with shortcomings yet so equally convinced of his abilities, the character of Monkey came ultimately to stand for the potential of the human personality to re-make and ultimately transcend itself.

Representations of monkeys in Chinese art are by no means confined to illustrations of *The Journey to the West*. Indeed, of all the positive characterizations accorded monkeys and apes outside the West, perhaps none

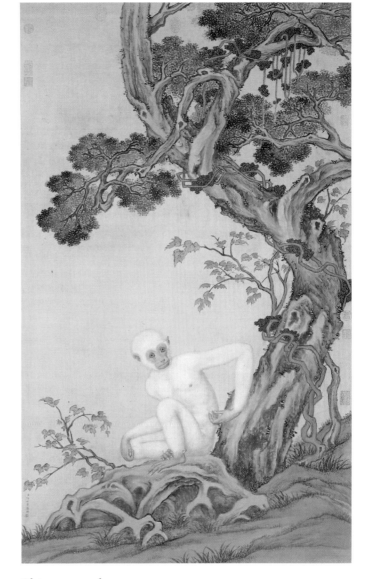

can rival that given by the ancient Chinese to that most mysterious and appealing of primates, the gibbon. Though rarely seen in the wild—it is reclusive by nature and its range in the remote mountain jungles of China was already severely curtailed by human incursion centuries ago—the gibbon has long played a central and almost entirely positive role in Chinese arts and letters.

Of the various good things the Chinese have had to say about the gibbon over the centuries, most revolve around

its supposed disinterest in the passions and cares of everyday life. In Chinese literature it is often contrasted to the smaller, noisier macaque (the star, by the way, of the Japanese monkey performance), an animal that in China as elsewhere could carry a good deal of negative associations. The macaque was charged above all as the representative of what Buddhist literature calls monkey mind, an ever-distracted, ever-impatient state of consciousness that constantly seeks novelty and excitement but never achieves any real satisfaction from them.

In contrast to the overbearing and unsophisticated macaque, the gibbon was seen as a natural aristocrat: In the words of Robert Hans van Gulik, author of a memorable and meticulous study of the gibbon's role in Chinese art and thought, he was "the *chun-tzu*, the 'gentleman' among apes and monkeys." Free from the macaque's restless dissatisfactions, the gibbon suggested to the Chinese exactly that disinterested yet attuned state of mind that both Buddhism and Taoism saw as the chief goal of meditative practice. The gibbon further encouraged this complimentary view of its character by spending most of its time high in the treetops, rarely venturing down to the ground. Aloof and at ease above the bustling lower realms where the plebeian macaque was king, the gibbon was seen as a kind of simian sage who went his dignified way without a thought for the intrigues and commotions that caught up and entangled lesser beings.

While this personality profile obviously reflects no small amount of projection of human qualities, it is a fact that gibbons are remarkably sophisticated animals, possessed of a great capacity for thought and emotion and capable of expressing these with a finesse that some argue surpasses even that of their fellow anthropoids the chimp, the gorilla, and the orangutan. Long-limbed and extremely graceful, gibbons live in small, monogamous family units that move through the tree canopy by means of impressive acrobatic leaps and brachiation, or swinging from arm to arm. The deep cries produced by gibbon groups in the morning and

Giuseppe Castiglione (1698–1768). The White Monkey. Painting on silk. A Jesuit court painter during the Ch'ing Dynasty, Castiglione pioneered the blending of Eastern and Western painting styles. Works like his White Monkey, won appreciation both from the Chinese and his fellow Europeans. National Palace Museum, Taipei, Taiwan, Republic of China.

at dusk have long been a staple motif in Chinese poetry and have served to add to the animal's general image as the embodiment of a life of the spirit unfolding above and beyond the corruptions of civilization.

After centuries of being designated as a lower craft, painting in China was at last elevated to the status of a fine art in the Sung dynasty (980-1279). During this time the amalgamation of Taoist and Buddhist values known as Ch'an or Zen Buddhism made its appearance, fostering a style of ink painting that strove not so much for the exact representation of a subject as for an intuitive expression of its inner or essential nature. At around the same time a parallel, highly realistic style emphasizing objective rather than gestural fidelity emerged and flourished as well, both approaches serving to complement rather than counteract each other.

Both these styles had their acknowledged masters, and of these, two stand out for their work featuring gibbons. The first is the Zen monk Fa-Ch'ang, otherwise known as Mu-hsi, a thirteenth-century master of the gestural style whose fluid yet supremely controlled paintings set wandering humans or animals like gibbons, deer, or waterbirds in compositions that are static, full of empty space, yet at the same time charged with a feeling of movement and hidden energy. Yi Yuan-ji, renowned for his work featuring animals of all kinds, brought a more conventional realism to his gibbons, but like those of Mu-hsi they move in a world of space and silence that at the same time suggests an all-pervading energy.

What most sets the surviving works of Mu-hsi and Yi Yuan-ji apart from so many others featuring monkeys and apes, both in the East and in the West, is not the charitable attitude they bring to their subject matter, nor the fidelity with which they have captured it, but a quality of direct perception that transcends both. Looking at Mu-hsi's famous *Mother Gibbon with her Baby*, for example, one senses that beyond whatever cultural, religious, or popular associations the artist intended this work to conjure up, there sits a pair of actual, living animals. Though scarcely objective in a rigorous, clinical sense,

Two porcelain snuff bottles featuring monkeys at play in a river landscape and around a peach tree. Jingdezhen, 1800–1880. Private collection, courtesy The Chinese Porcelain Co., New York.

this painting evidences a deep effort on the part of the painter to allow his own, specifically human perceptions to move out and meet with an alien creature existing in its own right, in its own domain, beyond the limits of the human world.

Like Dürer and the handful of other great Western artists who have allowed themselves to be touched and invaded by the presence of the animals they studied, Mu-hsi was very much a product of his time and the world-view of that time. But perhaps because in Mu-hsi's case that worldview was much influenced by Taoism and the spiritually charged egalitarianism toward the rest of creation that went along with it, his work is especially successful in conveying a sense of the animal as an actual, living consciousness. Mu-hsi's regard for the animals he painted, his willingness to go out beyond himself in order to encounter his subjects in their own, nonhuman arenas, was shared to one degree or another by a number of Chinese painters. The same spirit can be found at work in the Japanese masters as well (though due to the absence of gibbons in Japan, those featured there necessarily lack this sense of direct observation). Van Gulik, who during his time in China closely observed and interacted with captive gibbons, presents the following lines from a contemporary of Yi Yuan-ji, which appealingly convey the state of mind toward the natural world that is so evident in the work of Mu-hsi, Yi Yuan-ji, and their successors:

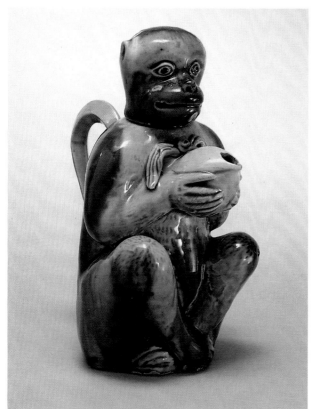

Turquoise and aubergine glazed biscuit figural wine pot. Kangxi period (1662–1722). Courtesy The Chinese Porcelain Co., New York.

> *He used to roam all over south Hupeh and north Hunan, going more than a hundred miles into the Wan-shou mountains, just to observe gibbons, deer and suchlike animals.*

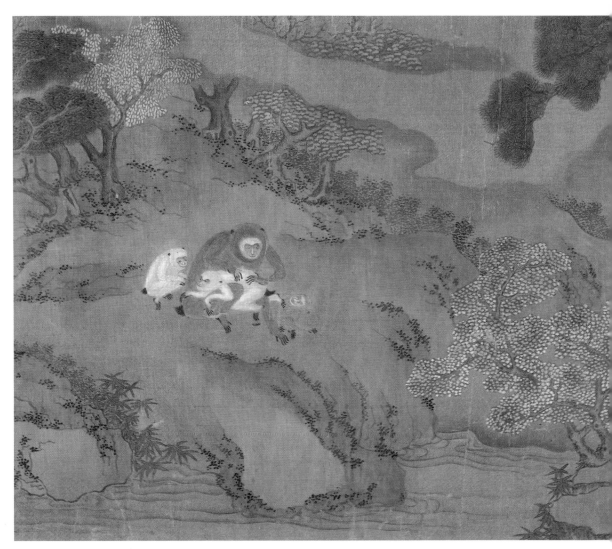

When he came upon a beautiful scene of trees and rocks, he
would absorb all the details one by one, thus acquiring ample
material on their natural properties and wild beauty. He used
to stay with the mountain folk, prone to lingering there for
months on end: his joyful love and unrelenting diligence were
like this. Moreover, he dug behind his dwelling in Ch'ang-sha a
few ponds, and placed among them rockeries at random, flow-
ering shrubs, sparse bamboo clumps and bending reeds, and
there he raised many waterfowl. He used to make a hole in the
windowpane to watch their behavior, both when playing about
and resting, thus to obtain material for his wonderful brush.

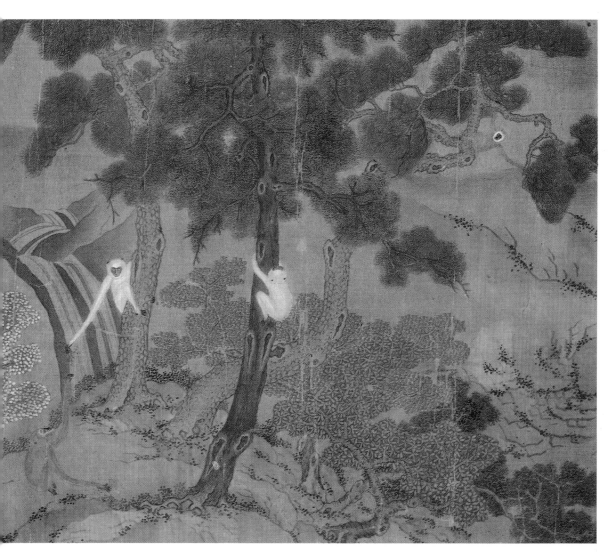

Gibbons in a Landscape. *Detail from a handscroll, ink and color on silk, eighteenth century. Landscapes full of gibbons have been persistently popular topics for painters both Japanese and Chinese. Often, the artist's imagination supplied activities for these animals that they would never have actually performed in the wild. Here, a mother gibbon appears to be ministering to her two children. Freer Gallery of Art, Smithsonian Institution, Washington, D.C.*

Natural History

As we have examined the abundant but widely scattered literature of our subject, we have been deeply and unfavorably impressed by the uncritical copying, quoting, or paraphrasing of author by author. Superstitions, surmises, rumors, accidental and unverifiable observations, inferences, and unwarranted conclusions, have been repeated through the centuries. It is a pity man should write so much, while observing, reflecting, and criticizing himself and his work so little._

So wrote Robert M. Yerkes, the first truly modern primatologist, in his classic 1929 study, The Great Apes. Certainly much the same criticism could be brought against the artists who have sought to visually record monkeys and apes in the name of science. Imitation of one's predecessors was the general rule here too, for it was typically much easier for an artist to consult existing drawings and his own imagination than it was to locate and observe a living animal.

This tendency to let fancy take the place of fact is on particularly vivid display in the great bestiaries of the Middle Ages. Essentially compendiums of Christian moralizing disguised as natural history, these often massive works combined the collected lore of antiquity with fresh inventions on the part of their authors to produce portraits of wild animals that today seem unbelievably farfetched.

At the close of the Middle Ages, religiously inspired timidity about accurate representation of the natural world gradually began to give way, and a new breed of highly exact nature illustration was born. Though increasingly unencumbered by lead boots, kidnapped human babies, and other such leftovers from the lore of former times, the monkeys of the new natural histories nevertheless continued to hold on to certain props from the past--especially the apple.

Engravings from Georges-Luis Leclerc, Comte de Buffon's Histoire Naturelle. *The first volume of this mammoth work appeared in 1749, and was ostensibly created for the amusement of Louis XV, but the vast catalogue of creatures presented there ended up influencing artists and scientists both in France and beyond for a number of years. The oddly polite poses struck by these simians are typical of the animals in the collection.*

RIGHT: *Macaque from an edition of Buffon's* Histoire Naturelle.

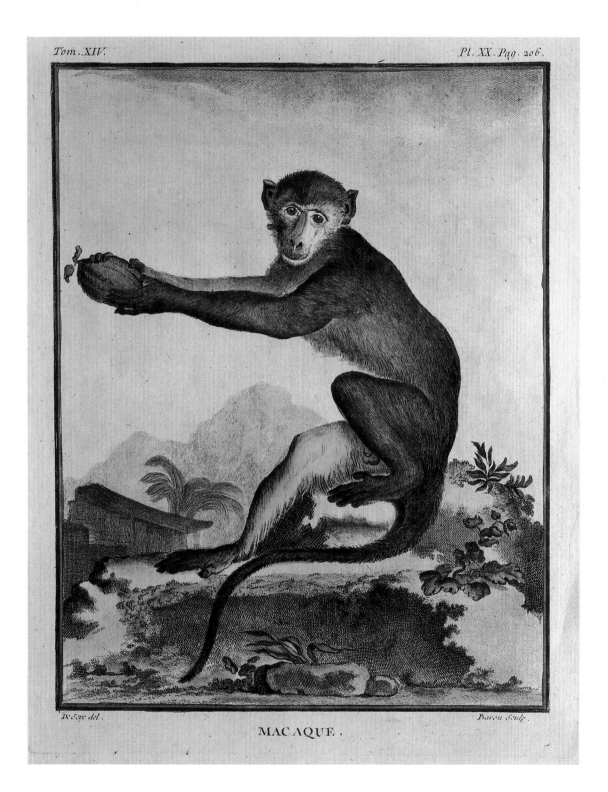

De Seve del. Baron Sculp.

MACAQUE.

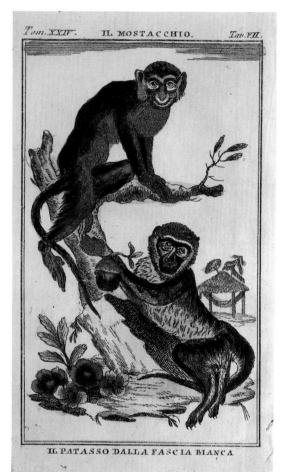

IL PATASSO DALLA FASCIA BIANCA.

IL COAITA.

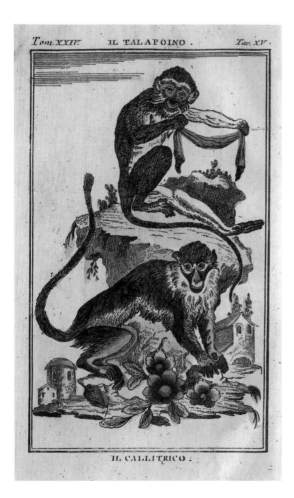

Four plates from the Italian translation of Buffon's Histoire Naturelle. *Printed in Naples 1850.*

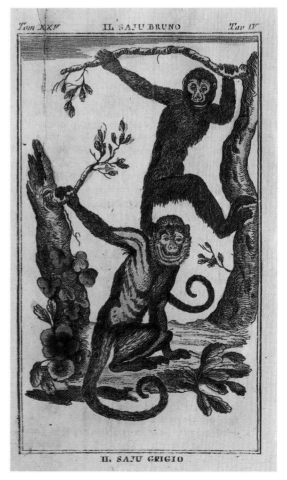

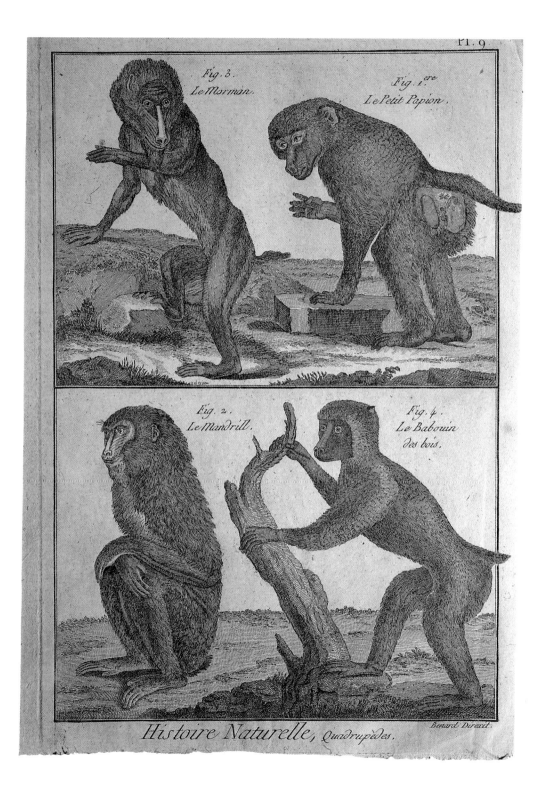

Fig. 3.
Le Morman.

Fig. 1.ere
Le Petit Papion.

Fig. 2.
Le Mandrill.

Fig. 4.
Le Babouin
des bois.

Benard Direxit.

Histoire Naturelle, Quadrupèdes.

Pl. 9

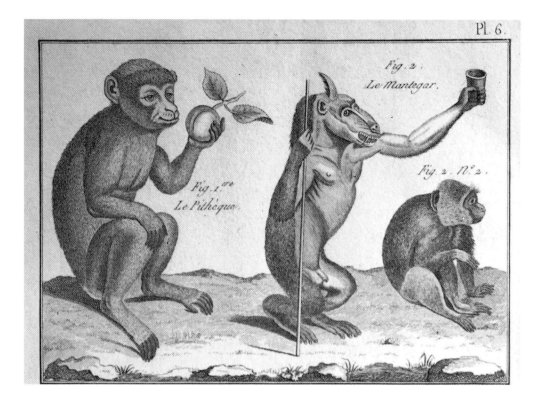

Pl. 6.

Baboons from Buffon's Histoire Naturelle. *Long before Europe's discovery of anthropoids like the chimpanzee and the gorilla, certain monkey species—especially the baboon—had raised difficult questions about where to draw the line between animals and humans. Encounters with societies of dog-headed men—perhaps based on garbled or inflated descriptions of baboon troops—were fairly common in the ancient world, and writers from Plato to Augustine addressed the possible significance of such accounts. Augustine went so far as to suggest that such creatures might possess human souls, and cautioned his readers against judging the "humanity" of a fellow creature on the basis of its external appearance alone. With the appearance of anthropoids in the seventeenth century, speculation on the intelligence of human-like creatures was reinvigorated, and the theory was advanced by several parties that these animals might be possessed not only of thought but speech, which they were timid about using among their European captors for fear that they might be put to work.*

The Nineteenth and Twentieth Centuries—Eden Revisited

Contemporary sprinkler featuring a monkey.

One of the oldest and most widespread stories in the world's catalog of myths and legends tells of a golden time of origins when human beings and animals lived as one, speaking the same language and enjoying a blissful freedom from the obligations of hunting and otherwise securing for their daily well-being. In these mysterious times the language of animals and the language of humans was one and the same; neither feared nor preyed upon the other, and the human sense of isolation, of not quite belonging to the rest of nature, did not yet exist.

Throughout the centuries artists have often felt drawn to include monkeys or apes in their visions of this lost age of innocence. Though the roles they play in these images vary greatly, the sheer consistency with which monkeys and apes show up in them is curious in and of itself. During the Middle Ages, monkeys appeared within the biblical Eden as symbols not of animal innocence but of the human failings of sin and vice that brought about the Fall out of it. In the primordial mists of Far Eastern landscape painting, on the other hand, they played the very different role of natural sages—the embodiments of just those qualities of purity, tranquility, and spirituality that most characterized the Far Eastern version of the lost paradisal age. In eighteenth-century Europe, when the craze for things Chinese gave birth to the rococo's whimsical and extravagant visions of China as a kind of historical paradise, monkeys again entered in force, this time suggesting a distant paradisal atmosphere even as they poked fun at the conventions of more nearby times and places.

This peculiar association continues into the nineteenth and twentieth centuries, where monkeys and apes frequently show up within images suggestive of paradise—most importantly the dark "Edens" of Henri Rousseau and Frida Kahlo.

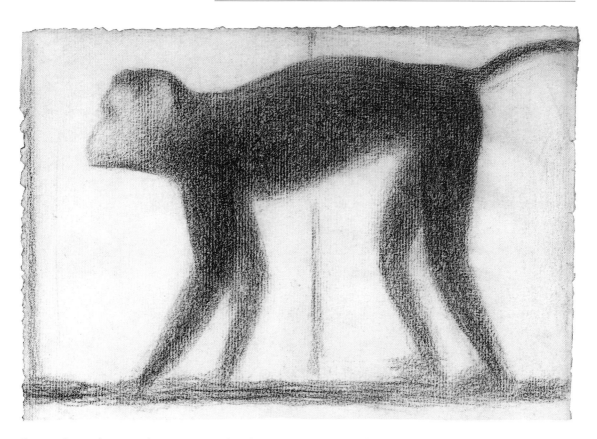

Georges Seurat (1859–1891).
Monkey. *This crayon drawing, made as a study for Seurat's* Sunday Afternoon on the Island of La Grande Jatte, *depicts what is most likely a capuchine, the monkey that traditionally accompanied organ grinders.*
The Metropolitan Museum of Art, New York. Bequest of Miss Adelaide de Groot, 1967 (67.187.35).

Like their predecessors, the monkeys of these new paradises represent a kind of halfway mark between the world of humans and a remote, wholly natural world in which humans no longer feel at home. But this time the lost land of innocence whose edges they guard is a vaguely sinister place—one that has no real parallel, either in the East or in the West, before the arrival of the modern age. The jungles from which these owl-eyed monkeys watch us are mute and passionless, "innocent" of human life and human meaning in a very different way than were the natural paradises of old. They are not the land of idealized, unfallen nature of Christian thought, nor are they its mirror image, the dark, demonic land of nature as it appeared after the Fall. Neither again do they share much in common with the luminous, spiritually energized landscapes of Far Eastern art. Instead they have something coldly biological about them, and their animal inhabitants share this quality. These new jungle "Edens" are places that are less, not more, than human.

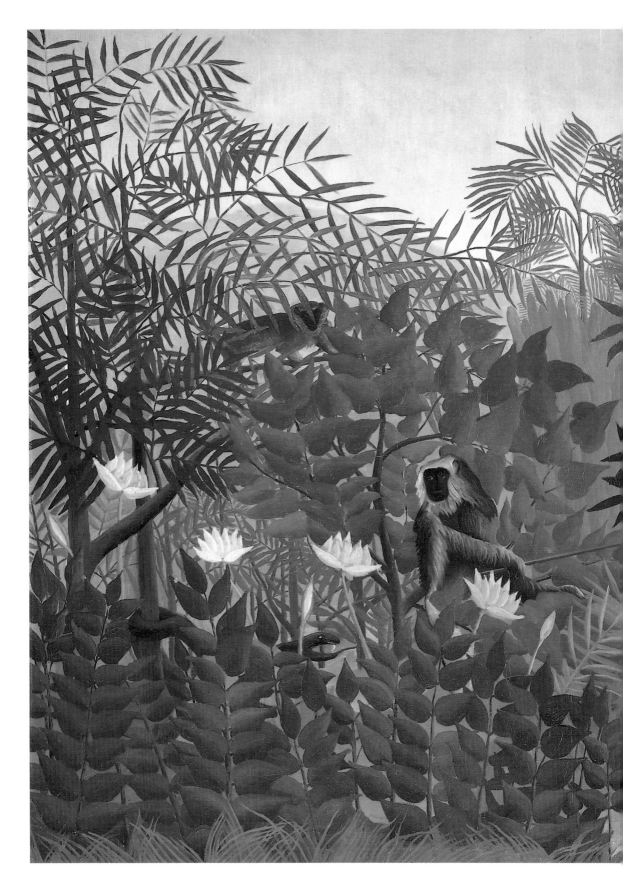

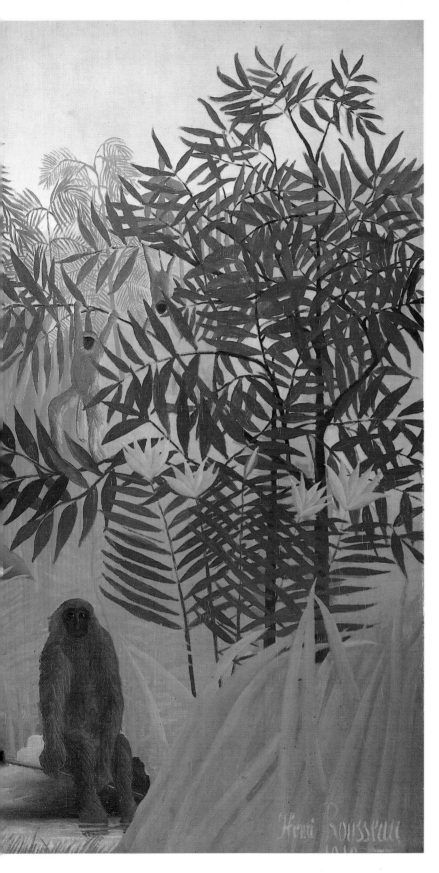

Henri Rousseau (1844–1910).
Tropical Forest with
Monkeys.
John Hay Whitney Collection.
National Gallery of Art,
Washington, D.C. *(1982.76.7).*

*Frida Kahlo (1907–1954). Self
Portrait with Hand. Collection
of Robert Brady. Cuernavaca,
Morelos, Mexico.
Courtesy Brady Collection.*

Francisco Goya (1746–1828). Los Caprichos number 41. Perfect Resemblance. *"He is quite right to have his portrait painted,"* writes Goya in his caption to this drawing from his famous early series Los Caprichos. *"Thus those who do not know him and have not seen him will know who he is."*
Prado, Madrid. Alinari/Art Resource, New York.

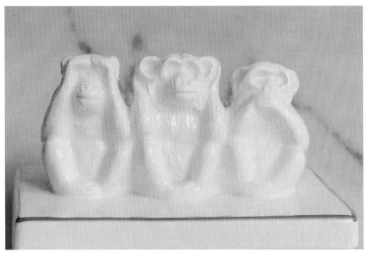

Abandon your airs! Head back to the state of animal innocence, where the odious and hollow duties of human culture can at last be left behind. So say both the cheerfully naked monkeys of Dürer's Monkey Dance and the immaculately appointed monkeys of Teniers's satirical paintings; and so too, with less tongue in cheek, do the very differently imagined primate subjects of Chinese painters like Mu-hsi and Yi Yuan-ji. The monkeys staring out of Rousseau's and Kahlo's jungle scenes also convey this message, but the return to innocence they offer is of a very different sort. For a Christian sensibility like that of Dürer or Teniers, that brazen invitation to animal freedom and innocence functioned as a useful counterpoint to the burdens and contradictions of life in human society, while for the ancient Chinese the gibbon's soulful call away from human concerns was a completely unambiguous ideal, to be regarded without irony or condescension. In the modern world of Rousseau's and Kahlo's canvases, on the other hand, that dynamic between responsibility and freedom has been lost, and replaced by a view of nature that is darker and more foreboding. The monkey's comfort with its animal nature, long pondered over with admiration or disdain, ends up here as a bleakly unconsoling reminder of the human sense of estrangement from the natural world. It is but a step from this attitude to the tormented superimpositions of animal and human forms created by Francis Bacon.

A typical Neapolitan creche figure from the nineteenth century. Monkeys have often found their way into creche scenes as part of the entourage of the Magi. Private collection.

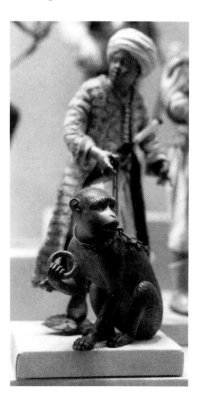

This artist's work with monkeys, and especially anthropoid apes, argues with unprecedented force that even if we could return to it, the original, untarnished world of nature is little more than an empty and terrifying machine.

It seems unfair to end this short look at the monkey's adventures in the world of art on such a grim note. Fortunately, there is a very different modern area in which monkeys have played a consistent and decidedly more cheerful role: that of children's art.

Pulcinella Attacked by Monkeys. *1920. Naples. Majolica Giustiniani. Museo Correale, Sorrento, Italy.*

Though sometimes forced into the role of buffoon or villain, the monkeys of this century's children's literature tend more often to reprise their old and venerable capacity as champions of freedom from rules and regulations—creatures who do what they want when they want, yet somehow escape getting into too much trouble for doing so.

Of course, children's books tend to be written by adults, so it is perhaps not so surprising that monkeys should once again be painted there as the happy enemies of adult rules and regulations. Nevertheless, it seems that the habit of seeing and celebrating monkeys as champions of freedom and irresponsibility is one that comes very early and easily to the human imagination. Wang Yani, the celebrated Chinese prodigy, began her painting career at age three, and for some time thereafter her subjects were almost exclusively monkeys. Yani's early watercolors are likably spontaneous and fresh, yet composed with a sense of balance and restraint remarkable for one so young. Perhaps equally remarkable is the fact that despite the three-year-old Yani's innocence of art history, the monkeys she painted from that age onward have about them exactly that combination of playfulness and disobedience that characterizes the monkey figure in so many other times and places. Some of them, perhaps in honor of their ancestors on the margins of the old Gothic Edens, are even clutching apples.

Mural by Ludwig Bemelmans at the Bemelmans Bar in the Carlyle in New York City.
Bemelmans, author of the "Madeline" series, decorated the walls of the bar at the
Carlyle while living there from 1946 to 1947 with his wife and his daughter Barbara,
after whom the character of Madeline was partially modeled.
Courtesy of the Carlyle Hotel, New York.

Advertisement for Dentol
toothpaste and powder. Aleardo
Terzi. Milan, 1911.

Cap. XIX

Pinocchio è derubato delle sue monete d'oro, e, per castigo, si busca quattro mesi di prigione.

Illustration by Attilio Mussino for Collodi's "Adventures of Pinocchio." 1927. In fables from the classical world, the monkey sometimes acted as a judge between animal disputants.

RIGHT: H. M. Brock (1875–1960). Illustration for Beauty and the Beast. E. T. Archive, London.

Fishing, *and* These Fruits Are
Not Yours *by Wang Yani*
painted at age five.
Courtesy of the Cultural Office
of the Consulate of the People's
Republic of China, New York.

Michelangelo (1475–1564). Unfinished figures for the tomb of Julius II.
Financial difficulties prevented Michelangelo from completing the tomb for
which these two clinging monkey figures were intended. Beautifully realized
even in their unfinished form, they were probably meant to suggest either the
fine arts, which "ape" the world of nature, or the downward pull of the flesh
against which the human spirit must constantly struggle.
Louvre, Paris. Photo R. M. N., Paris

Selected Bibliography

Clark, Kenneth
Animals and Men: Their relationship as reflected in Western art from prehistory to the present day.
William Morrow and Co., 1977.

Dance, Peter S.
The Art of Natural History.
The Overlook Press, 1978.

Delbanco, Dawn Ho.
"Monkeys in Chinese Art and Culture." In *Yani: The Brush of Innocence.*
Hudson Hills Press, 1989.

Honour, Hugh.
Chinoiserie: The Vision of Cathay.
John Murray, 1961.

Jacobsen, Dawn.
Chinoiserie.
Phaidon, 1993.

Janson, H. W.
Apes and Ape Lore in the Middle Ages and the Renaissance.
The Warburg Institute, University of London, 1952.

Kherdian, David.
Monkey: A Journey to the West. A retelling of the Chinese folk novel by Wu Ch'eng=en.
Shambhala, 1992.

Klingender, Francis.
Animals in Art and Thought to the end of the Middle Ages.
MIT Press, 1971.

Levey, Michael.
Rococo to Revolution: Major Trends in Eighteenth Century Painting.
Thames and Hudson, 1985.

McDermott, William C.
The Ape in Antiquity.
The Johns Hopkins Press, 1938.

Narayan, R. K..
The Ramayana: A Shortened Modern Prose Version of the Indian Epic.
Penguin Books, 1972.

Ohnuki-Tierney, Emiko.
The Monkey as Mirror: Symbolic Transformations in Japanese History and Ritual.
Princeton University Press, 1987.

Snead, Stella.
Animals in Four Worlds: Sculptures from India. With Essays by Wendy Donniger and George Michell.
University of Chicago Press, 1989.

Toynbee, J. M. C.
Animals in Roman Life and Art.
Cornell University Press, 1938.

Van Gulik, Robert Hans.
The Gibbon in China: An Essay in Chinese Animal Lore.
Leiden, Brill. 1967.

West, John Anthony.
The Traveller's Key to Ancient Egypt.
Alfred A. Knopf, 1985.

Yerkes, Robert M.
The Great Apes: A Study of Anthropoid Life.
Yale University Press, 1929.

Yu, Anthony C.
The Journey to the West.
University of Chicago Press, 1982.

Girolamo da Cremona Fifteenth century. All Men Desire by Nature to Know. *Artists have long enjoyed putting monkeys into the clothes not only of the wealthy and pompous but of the learned and wise as well. Here, an illustrious company of thinkers is pictured contemplating Aristotle's Metaphisics. They are joined by a cogitating monkey, whose attention seems to be focused elsewhere. Aristotele Opera published in Venice in 1483. Vol.II Purchased by J. P. Morgan, Jr. 1919,*
The Pierpont Morgan Library, New York, PML 21195 (ChL ff907).

Omnes homines natu-
ra scire desiderant. Si-
gnū aūt est sensuū dile-
ctio:preter enī vtilitate
...propter seipsos diligūtur
... maxie alioꝛ qui est
per ipsos oculos. non
enim soluꝫ vt agamuꝫ
sed ꜩ nibil agere deben-
tes: ipꝫ videre pre oib9
vt dicam alijs eligim9. causa aūt est quia bic ma
xime sensuū cognoscere nos facit. ꜩ multas rer
differētias demōstrat. Alialia quidē aūt sensuꝫ
babētia natura sūt. ex sensibus aūt qbusdā qdē
ipsoꝝ memoria non fit: quibusdā vero fit:ꜩ ꝓꝑt
boc alia qdeꝫ prudētia sunt:alia vero disciplina-
biliora non potētibus memozari. Prudentia
quidē sunt sine addiscere quecūꝫ sonos audire
nō potētia sunt:vt apes. ꜩ vtiꝫ si aliqꝫ aliud ge-
nus animaliū buiusmodi est.addiscūt aūt que-
cūꝫ cum memoria:ꜩ bunc babēt sensum. Alia
quidē igitur imaginatiōibus ꜩ memorijs viuūt:
experimēti aūt parū participāt: bominū aūt ge-
nus arte ꜩ ratiōibus. Fit aūt ex memoria bomi-
nib9 experimētū:eiusde nāꝫ rei multe memorie
vnius experiētie potentiā faciunt:ꜩ fere videt sci
entie ꜩ arti simile experimētū ee. bominibus
aūt scientia ꜩ ars per experimentū euenit.expiētia
quideꝫ enim artem fecit: vt Ptolemeus recte di
cens:sed inexpientia casum. Fit aūt ars cum ex
multis experimentalibus ꝓceptibus vna fit vni-
uersalis velut de similibus acceptio. acceptionē
enim quidē babere: ꝙ callie ꜩ socrati bac egritu
dine laborātibus bec ꝓtulit:ꜩ ita multis singula
riū experimenti est. Quod aūt oibus buiusmo-
di ꝼm autē vnam specie determinatio bac egritu
dine laborātib9 ꝓtulit:vt phlegmatice aut cho-
lericie aut estu febricitātibus artis est. Ad agere
quidē igitur expiētia nibil ab arte differre videt:
sed ꜩ exptos magis ꝓsicere videmus sine expiē-
tia ratiōe babēubus.causa aūt est quia experie
tia singulariū est cognitio: ars vero vniuer-
saliū.actus aūt ꜩ oēs generatioēs circa singlare
sunt.nō enim bominē medicus sanat nisi ꝼm ac
cidēs:sed aut callia aut socratē aut aliquod sic di
ctoꝝ:cui ee bominē accidit. si igitur sine experi
mēto quis ratioes babeat:ꜩ vniuersale quidē co
gnoscat: in boc aūt singulare ignoꝛet:multocies
quidē curatiōe peccabit:singulare nāꝫ magis
curabile est. Sed tamē scire ꜩ intelligere magis
arte q̄ expimēto ee arbitramur: ꜩ artifices exp
tis sapientiores ee opinamur:tanꝫ magis ꝼm
scire sapiētia oia sequēte.boc aūt est:quia bi qdē
causam sciūt:illi vo non.expti quidē enim sciunt
ipm quia:sed ꝓpter quid nesciūt: illi aūt ꝓpter qd
ꜩ causam cognoscūt.vnde ꜩ architectoꝛes circa
quodlibet quidē buiusmodi bonorabiliores ꜩ
magis scire manu artificibus putamus ꜩ sapien
tiores:quia factoꝛ causas sciūt: illi vo sicut qdā
inanimatoꝝ faciunt quidē: non scientia autem
faciunt que faciunt: vt ignis quod exurit. inaia
ta quidē igit natura qdā vnūquodqꝫ boꝛuꝫ
facere sed manu artifices propter consuetudine
est tanꝫ non ꝼm practicos ee sapiētiores sint
sed ꝼm ꝓ ratione babēt ipsi ꜩ causas cognoscūt
Et oio scientis signū est posse docere: ꜩ ob boc
artem magis experimento scientiā ee existima
mus. Possunt aūt bi:bi aūt docere non pos-
sunt:amplius autē sensuū neqꝫ vnū sapientiā
ee ponimus cum bii singuloꝛ cognitioēs ma
xime proprie sint: sed ꝓpter quid de nullo dicū
ut propter quid ignis calidus sed quia calidus
solum sit. Pꝛimū quidem igitur conueniens est
qualibet artem inuenientes vltra cōes sensus ab
bominibus mirari non soluꝫ propter aliquaꝫ in
uentoꝛ vtilitatē sed sicut sapientē: ꜩ ab alijs dif
ferente. pluribus autem repertis artibus ꜩ alijs
quidē ad necessaria: alijs vo ad introductionē
existentibus.tales illis sapientiores ee arbitrā
dum est propter id qꝫ illoꝝ scientie ad vsum nō
sunt.vnde iam omnib9 talibus institutis que nō
ad voluptatē neqꝫ ad necessitatem scientiarū re
perte sunt. ꜩ pꝛimū in bis locis vbi vacabāt: vn
circa egyptū mathematice artes primū consti
tuerunt:ibi nāꝫ gens sacerdotū vacare dimissa
est. In moralibus quidem igitur que sit artis

We wish to thank Nicholas Sapieha for
his help and for the photos
on the following pages:
12–13; 58–59; 66–73; 76–79.

Design by: Our Designs, Inc., New York
Natasha Lessnik, Art Director

Color separation by Sfera, Milano
Printed and bound in Italy by Sfera/Garzanti

The author wishes to thank the following
for permission to quote from published materials.

Charles Janson for passage from H. W. Janson's
Apes and Ape Lore in the Middle Ages and the Renaissance.
Viking Penguin for a passage from R. K. Narayan's *Ramayana.*
Yale University Press for a passage from
Robert M. Yerkes's *The Great Apes: A Study of Anthropoid Life.*

TEXT SET IN DANTE FROM THE MONOTYPE FOUNDRY.